LIVING MY DREAM:
The 50th Anniversary Celebration

By Synthia SAINT JAMES

ISBN-13: 978-1718800625
ISBN-10: 1718800622

DEDICATION

For my Mom
Hattie Marie Ferguson DeSalle James

INTRODUCTION

Dr. Synthia SAINT JAMES has set out to create yet another brilliant work of art. This time, she uses the canvas of her life to reveal to us through the pages of her book an extraordinary guide to success, based on her.

She has taken her remarkable accomplishments and given us all a clear view of how to use her successes to inspire our own. We can glean from what she has written exactly what to do to market what we have created and to live our dreams.

On a personal note, my eternal gratitude goes to Synthia for allowing the painting *Precious*, her collaboration with artist Charles Bibbs, to appear on the cover of my first major book, Africana Woman ~ Her Story Through Time, published by National Geographic Books. For me, this book was my lifelong dream come true.

There can be no doubt that some of your greatest dreams, too, have been realized. There are other nascent dreams in our hearts, however, that are still waiting to spring free. When those dreams continue to seek our attention, and we open ourselves to making them possible, every fiber of our existence comes to our aid. All we need to know in most cases is what steps to take.

This is the beauty of Synthia's book. It is full of practical possibilities. *Living My Dream* gives anyone and everyone concrete ideas about how to market each nuanced thought until it becomes a glowing reality.

This book encourages us to stop dreaming and to start doing. Synthia's lifelong journey is a shining example creating and releasing...

Whether through her affirmations, or her marketing tips, you will be drawn into the realm of the possible. Each page encourages us to set aside our fear and doubt and to "go for it" with courage and expectation in golden light, as Synthia does every day.

It is a joy to know Synthia. Never have I met such a positive person and a living exemplar of how to live each moment to its fullest capacity. Once you begin this easy yet powerful read, you will know that your time has come to live your life's purpose fully. After all, there is no time like the present to live a fulfilled existence. Let the joyful journey begin...

Dr. Cynthia Jacobs Carter

PREFACE

I am privileged to call Synthia SAINT JAMES one of my best and dearest friends. We were destined to meet which is why when President Tyree Weider of Los Angeles Valley College - where I was the Director of the Foundation - casually mentioned that Dr. SAINT JAMES had attended LAVC, I set out to find her.

We met at a prestigious event where Synthia was being honored. Immediately, I was struck by her outgoing and easy personality. The vibrant colors depicted in her work are synonymous with her life.

We connect on many levels such as the love we share for travel, nature, oceans, mountains, world music, dance, poetry, lyrics and most of all, children. Synthia loves and is inspired by the enormous curiosity of children.

Her mother, Hattie, knew she would be a great teacher someday. She might not have known that Synthia's classroom would take on different shapes and sizes as she paints and pens her lessons on canvasses, book covers, commissioned art, manuscripts, public art, poetry and lyrics.

Welcome to the world of Dr. Synthia SAINT JAMES! You are about to embark on a journey exploring a body of work with a global footprint. I trust that you, too, will be as in awe as I am.

Barbara A. Perkins, Life Coach and Author

AUTHOR'S PREFACE

At the tender age of five, I was already dreaming of making my living as an artist when I grew up. That dream stayed with me throughout my childhood and into adulthood until I made it my reality.

I have a few reasons for writing this book. It is my hope that by sharing my journey, you will be inspired to follow your dreams and passions. I also hope that you'll save some of your precious time and possibly money by learning from my mistakes and from other experiences shared by way of my marketing tips.

In addition, I've been teaching a class titled ***The Business of Art Workshop*** for several years at colleges, universities and cultural centers. By writing this book, I can share far more information than in those short class sessions.

Synthia SAINT JAMES

CHAPTER ONE
My Calling

I was born in Los Angeles, California, on February 11, 1949. When I was two years old, our family returned to Bronx, New York where my parents were born and raised. I lived in New York between ages two and six and again, between age eighteen and twenty-three. I call these years "my wonder years of growth."

The rest of my life, I've lived in Los Angeles. I am definitely a product of both places and I love them for many reasons so, yes, I am a New Yorker and a California girl.

Regarding my calling to the visual arts, I was no child prodigy who showed some amazing talent or potential; I just enjoyed coloring and drawing like most other young children. Nevertheless, I do somehow remember having strong feelings about becoming a "real" artist.

CHAPTER TWO
Los Angeles, California

In the 1960s, the most practical career choices for women, especially African American women, were in teaching, nursing and secretarial work. I considered teaching primarily because my mom suggested it with these words, "If you become a teacher you'll have your summers free to paint."

At the time, this sounded like a good compromise. Therefore, after graduating from Los Angeles High School in the winter of 1967, I became a full-time student at Los Angeles Valley College in Van Nuys, California, majoring in liberal arts.

I also started my first job where I earned a paycheck working part time at Grauman's Chinese Theatre in Hollywood, California. I was the first African American hired by the theatre because of the threats of boycott they received from a major Black organization.

However, I was still determined to eventually have a successful career as a full-time artist, even though I hadn't a clue about how to realize my dreams in my lifetime.

In late August 1967, my family moved back to Bronx, New York. That summer, I interviewed and landed my first accounting job at Macy's 34th Street.

I moved upstate to Poughkeepsie, New York, in January 1968 to attend Dutchess Community College for one year. Again, I majored in liberal arts.

CHAPTER THREE
New York, New York

After three semesters of college, I decided to take a break from my studies. I needed time to think. I felt so far away from my true goals and passions. At first, I convinced myself that it was just a temporary break, hating the fact that I may disappoint my parents.

I would soon realize that my true desire was to pursue my artistic dreams right away. However, I knew that I first needed a full-time job to support myself. Shortly after my move back to Bronx, New York, I was hired as a file clerk at Security Title and Guaranty Company, a mortgage insurance company in Manhattan.

I soon found out that I was hired immediately because of my neat handwriting. (When I was thirteen years old, I created my own unique style of printing and I guess it stood out.) In less than a month I was promoted to a new position in the accounting department as the accounts receivable clerk. I was trained by the head accountant for the firm.

Later in my art career, I would use accounting to earn supplemental income and I still use it for my record keeping and taxes for my art business.

CHAPTER FOUR
Public Relations: The Beginnings of a Learned Skill

If you've ever worked in an office or on any "regular" job, you know that the biggest topic of conversation is generally about your time spent away from work. You're asked about what you did over the weekend, on holidays and on your vacations. Therefore, it was easy and I was eager to share the fact that I was an artist with great aspirations and that I spent almost all my spare time painting.

Before long, I was asked to create charts for company meetings along with other small art related tasks. These tasks were in addition to my accounts receivable duties. And yes, I did ask for a raise.

This all began right after I discovered a wonderful art supply store near my office. On paydays, I would buy art supplies and while experimenting, I began painting abstracts to hang on the walls of my apartment. Of course, my coworkers noticed me coming back from lunch breaks with bags of art supplies.

On one of those days, an attorney at Security Title, Daniel Fischman, asked me about my artwork and I described my abstracts in great detail. He must have been intrigued because he asked if I would consider painting an abstract for his apartment. This came as a complete surprise, but I definitely accepted his offer. This was my first commissioned work and my first sale. I was twenty years old.

When I delivered Daniel's painting to the office, everyone wanted to see it. I was feeling a bit shy, but his excitement made it easier to share. Everyone liked it. A few coworkers began asking me about painting pieces.

I didn't know it then, but delivering the painting to Daniel in an environment where others would see it proved to be a great art marketing tool. In marketing, this occurrence is called the bandwagon effect.

With the bandwagon effect, desire for your product (or service) is created from another's use of your product (or service). In essence, X has it, so I want it, too! Daniel's purchase created a frenzy of others wanting to buy. He was, however, one step ahead of them and immediately commissioned me to do a second painting.

Art Marketing Tip:

1. Don't feel shy! Let people know you're an artist. Most people are very intrigued by artists and will help you spread the word, which will often lead to more sales.

At that time, artists who displayed and sold their artwork on the streets of Greenwich Village in New York City averaged about $75 for an abstract painting measuring 24-inches x 36-inches. That was the fee Daniel suggested and I agreed. To give you a perspective, in 1969, my one bedroom furnished apartment in a nice neighborhood in Bronx, New York, rented for $125 per month.

I was in shock and awe about this commission opportunity. I could actually do something I enjoyed and get paid for it. This was unbelievable to me at the time, but my dream was becoming a reality.

Art Marketing Tip:

2. Research is very important to the pricing of your artwork. Find out what other artists who are at the same level in their careers are asking and receiving for their artwork.

With my first earned income from selling this painting, I bought more art supplies, a couple of gifts and a Polaroid camera to document my work. At that time, I just called it "taking pictures." Looking back, I would say that this was my first art marketing decision.

Don't make the mistake I made. I didn't continue this practice and later, I would regret not having any visuals to show for all the paintings I painted and sold in my early years.

Art Marketing Tips:

3. Documentation is of the utmost importance. Have the paintings you plan to release as fine art reproductions or for licensing opportunities scanned professionally onto a CD as tiffs and jpegs at a color lab specializing in artwork. You'll be able to get more work based on the work you've already done, not to mention you'll gain access to the many licensing opportunities available for existing artworks.

4. Store the CD's in a safe place. I'd suggest either looking into renting a safe deposit box at a bank or at least investing in a small to medium size fireproof safe to keep in your home. You can buy a safe at most office supply stores or online.

The Effect of the Bandwagon
In the eyes of my coworkers, I was already a successful artist. (They believed in Daniel's choice and wanted to "come along for the ride.") Thus, a string of commissions followed from these coworkers. Even my supervisor got on the bandwagon!

As a result, I began to realize that my dreams could truly be my reality. People were actually buying my paintings and displaying them prominently on their walls. The word continued to spread as people showed their paintings to their friends and relatives.

I began getting commissions outside of my office. The first outside commission came through my cousin, Elaine, as she shared photos of my work with the president of the company where she worked.

It was quite a sight to see me carrying supplies home or delivering finished paintings on the subways, mostly during rush hour. At only 5'2" my paintings were often larger than me!

Art Marketing Tip:

5. The bandwagon effect can occur at exhibitions, too. Once a person purchases a piece of artwork, one of their friends, a family member or just another person at the exhibit will want to purchase something for themselves.

Often, they'll want the same piece that the person just purchased. If this is a fine art reproduction with multiple copies, let them know you have others available. If this is an original painting, you can offer to create a similar or special commissioned painting for them.

CHAPTER FIVE
Commissions Galore

For the next couple of years, I continued to work at Security Title and sold my commissioned artwork to coworkers as well as others outside of our office. This was still due to word of mouth and the bandwagon effect.

Unfortunately, with working full time, my painting time was very limited. Still, I was now a professional artist, fulfilling a large part of my dream.

After the experience of my first trip outside of the United States to Barbados in the Caribbean and Guyana, South America, I decided it was time to move back to Los Angeles. The tropical atmosphere of both countries and the people reminded me of home.

Being self-taught, I was completely surprised by the number of people who wanted to commission me to paint something for them before my move.

During those early years in New York, my excitement at being commissioned was truly greater than my business sense because I never once had a client sign an agreement or contract. I was truly fortunate because all my clients proved to be trustworthy.

I planned to move back to Los Angeles in a year, soI started saving my money. I worked one full-time job at Security Title and later that year for Phoenix House. In addition, I worked part-time jobs for both New York Life Insurance and Fuller Brush Products on weekdays.

This left me only weekends to work on my commissioned paintings. This was a lot of work and I put in long hours, but I was determined to reach my goals of moving back to Los Angeles and building my career as an artist.

Art Marketing Tip:

6. Money in the bank is essential for your peace of mind on all levels so always maintain a savings account. Whether you're planning a location move or an investment in your art career, including publishing a limited edition, it's always good to know that you have some money to fall back on.

Handling Commissions
At the time, I did my best to fulfill several commissions. After I moved back to Los Angeles, however, I realized just how many commission opportunities I lost.

I should have accepted and completed all those commissions in Los Angeles. It would have been so easy to ship the artwork back to my clients. One of the wonderful things about being an artist is that you can virtually paint anywhere, at any time and sell worldwide.

Art Marketing Tip:

7. If your time doesn't permit you to work on a project immediately, recommend scheduling it for a later date. The client will respect your talents more for the demand on your work.

CHAPTER SIX
Establishing Myself

It took me years to establish myself as an artist in Los Angeles. I had none of my paintings with me and I had only a few visuals to show for my four years of commissioned work. Somewhere along the way I had dropped the ball. I had stopped documenting my work.

Art Marketing Tip:

8. Showing samples will certainly help promote sales. Always have up-to-date visuals of all your artwork to show potential buyers.

A 24/7 JOB

After a brief time back in Los Angeles I landed a job at Shelter Records, a small record company. Shelter Records is the company that discovered Phoebe Snow and later signed other groups, including The Gap Band.

They also had a Reggae label, Mango Records, and their records were distributed by Capitol Records and later by MCA. I was initially hired as the receptionist, but in less than two months, I was promoted by Dino Airali to Assistant National Promotions Manager.

I learned a lot at Shelter Records, especially about marketing. My duties included promoting recording artists, concerts and other musical events. I later worked in the fields of publicity, art and advertising and in international

music publishing before I was promoted to Assistant General Manager.

As part of my job as Art and Advertising Manager, I interviewed visual artists, graphic designers and photographers for album cover art designs - jobs I would have loved to have done.

I was so busy marketing other people that I didn't have time to paint. The record business is a 24/7 job with concerts and events to promote and attend after our regular working hours. During my time with Shelter, I only managed to paint one painting.

Art Marketing Tip:

9. No matter how many other jobs you may have to work in your lifetime, always find something in them that you can apply to your art.

CHAPTER SEVEN
Leaving Shelter

One of Shelter's freelance graphic designers called one day out of the blue and asked if I'd be interested in interviewing for a job at Paramount Pictures. He explained that a writer friend of his, Sal Gianetta, had just been hired to adapt his novel into a screenplay and he needed an assistant.

I was tired of all the hard work and long hours that came with my position at Shelter, so I interviewed and landed this dream job. My ultra-busy days and nights immediately began to free up because there wasn't much to do for my new boss. He enjoyed doing almost everything for himself!

I picked up and read the daily trade magazines, Variety and Hollywood Reporter. While he worked on his screenplay in his office, I got back to my writing. I had been writing poetry for years and started writing bios for recording artists while at Shelter Records.

This routine soon changed. Sal would call in every morning around 11:00 a.m. to check in and see what was going on. He tried writing in an office setting and had even turned down the lavish suite of offices first given him on Paramount's lot, the suite of four offices where the book *Valley of The Dolls* was adapted into a screenplay by the author, Jacqueline Susann. He just preferred writing at home.

On most days he'd just say, "Kiddo, go on home and paint." That meant I would arrive at the office by 10:00 a.m. and leave usually by 2:00 p.m. A far cry from my record business schedule!

I was painting again! I felt extremely fortunate for the time that was given me to do so and for the financial cushion this job provided. Though this period didn't last long, it did get me back on track with my career as an artist.

Art Marketing Tip:

10. Time is a gift, use it well.

CHAPTER EIGHT
The Performing Arts

So many doors of opportunity were opened to me when I first moved back to Los Angeles. One was modeling, so I did a little print modeling. At the suggestion of one of my photographers, Roland Charles, I enrolled in an acting class. He suggested that it would make me feel more comfortable in front of the camera.

I enrolled in classes at Inner City Cultural Center. I took Theater Acting and Improvisational Acting classes from Glynn Turman and Jazz Dance and Katherine Dunham Technique from various incredible New York dancers, including Winston Hemsley.

I caught a very small acting bug and I worked professionally from about the mid to late seventies. Acting helped me in my art career with people skills. Once you're more comfortable with yourself, you're more comfortable with others in any given situation.

Soon after my job ended with Sal at Paramount Pictures, I took a commercial acting class, *The Commercial Way*. My instructor's primary concern was my thick New York accent, which was not favorable when auditioning for national television commercials.

So, I learned how to speak without my accent and after numerous commercial auditions, I finally landed a national McDonald's television commercial as the spokesperson. The slogan was "Take Us Along" and I played a 17 year-old McDonald's counter girl.

This commercial was a true gift. The residual checks that seem to appear out of nowhere in my mailbox enabled me to stay home and paint for six months. Delightful!

For the first time in my life, I was able to completely indulge myself into painting. I decided to stop auditioning and for a time, concentrate all my efforts on my fine art.

I became an inactive member of Screen Actors Guild. I would retain my membership and activate my full membership status at any time in the future. I was not required to pay dues until I made active my full membership.

After 6 months, the residuals stopped and my "starving artist" period truly began. I had six month's worth of paintings, however, to show for it. While attending Inner City Cultural Center in 1977, I held my first solo exhibition there complete with the opening wine and cheese reception.

Art Marketing Tip:

11. Seek out and make the most of every opportunity.

CHAPTER NINE
Disney Studios

I began looking for a part-time job that would allow me to paint at least a few hours a day and paint one full day and a half on weekends. In fact, Sunday is still my favorite day to indulge myself completely in painting.

I read in the newspaper that Disney Studios in Burbank, California, was interviewing for new positions. So I called and set up an appointment with their personnel department and was hired that very day.

I worked in the Educational Media Department and my supervisor was Vonda Lee Binko. She definitely had a large place in her heart for all artists, visual and performing.

At Disney, we were called "zippers" because our job was to look up zip codes for various schools and then enter them into Disney's computer database for mailings. This was in the late seventies and computers were just becoming an integral part of our world.

My shift was from 1 p.m. to 5 p.m., Monday through Friday. I chose this schedule because I'm at my creative best in the morning. I generally painted for 3 to 4 hours every weekday and then I caught the bus to work.

My shift mate, Doug Bonner, who was studying to be a film maker, and I grossed about $4.50 an hour or $90 a week. We were truly starving artists. He was tall and skinny and I was short and skinny - weighing in at about 100 pounds. We both had long curly hair and I'm sure we were visually quite a pair.

We soon found that Disney's commissary had excellent food at very inexpensive prices, so most days we would arrive about an hour before our shifts and take full advantage of this wonderful perk. We would choose from a variety of delicious, complete, hot meals which cost us under $2. In no time, the commissary staff took pity on us. They would always pile our plates high with whatever we ordered. I'm sure they were trying hard to fatten us up.

This was in the late seventies when I was painting wild and domestic animals. When I found out through Vonda that the animation department's library exhibited the artwork of Disney employees, I realized again that I was working in my perfect place.

There was opportunity knocking. If my artwork was accepted for an exhibition, I could add Disney Studios to my resume. That listing alone would serve to impress. Immediately, I put together and submitted a neat portfolio of photographs of my paintings, a current bio and a resume.

Art Marketing Tip:

12. Look for exhibition possibilities everywhere. In your community's libraries, schools, churches, office buildings and centers. Exposure is a must for artists. You'll never know who may see, buy or commission you once they have seen your artwork.

CHAPTER TEN
Menagerie

My artwork was accepted for an one month exhibition which I titled **Menagerie**. I had a wonderful and successful exhibit at Disney Studios. Not only did I sell a few paintings - even one to the then President of Disney's Board of Directors - I was given a pro bono consultation on the ins and outs of copyright by a Disney staff lawyer.

The animation library was even open to me for research, allowing me to borrow from their vast collection of photographs of animals. Also, as a Disney employee, I was also able to borrow animated features and a screen and projector to take home on weekends. I definitely enjoyed having screening parties for my adult friends. We'd watch all the Disney classics, including **Bambi, Pinocchio,** and **Lady and the Tramp.**

Later that first year, I was asked if I would be interested in submitting an application for a special Disney animator program. Accepted applicants would learn how to create their own short animated films and would then be eligible to apply for a full-time Disney animator's position.

This was very intriguing to me and I really gave it some deep thought, especially since I've always loved animation. My possible future job consisted of sketching sequences, frame by frame, for the animated films. This means sketching still frame movements of the progression of a character from one place to another.

Upon completion, these sketches would then go to another team of artists that would supply more detailed drawings. The film that was currently in production was **The Fox and the Hound**. To be considered, you first had to fill a sketch book with drawings of animals. So I ventured out to the Los Angeles Zoo with a sketch book to test my skills.

When I found that I really couldn't get into it, I remembered that I've never enjoyed sketching. I happen to be an artist that just loved to paint.

Then, just to make sure that I wasn't just letting my nerves get in the way, I decided to talk to some of the Disney animators I met through my friend, Drew Muldrow. I wanted to know how they really felt about their jobs and if any of them created art for themselves anymore.

The overwhelming response was that art had become their 8 to 5, clock in clock out, JOB. Not one of them created art for themselves anymore. This is when I decided that I would always use the left side of my brain when working for others, and save the right side for my art.

Art Marketing Tip:

13. If you are truly dedicated to your art, be sure that you don't choose any means of financial support that would dilute your creative passion. You don't want to lose it.

CHAPTER ELEVEN
Shelter Revisited

For a time, the only other job that looked like a good fit at Disney was "traffic." The traffic department handled all mail, including interoffice correspondence. If I had of gotten a job in traffic, I may have stayed a little longer, enjoying riding a bike all over the studio lot delivering mail.

Financially, however, I couldn't stay any longer. I needed to get a full-time job again, even though I've always thought of working full time as a temporary fix. My art would triumph in the end.

I worked at Disney for a little over a year when my old record company offered me a temporary job and I went back to Shelter Records. I answered phones, sent out telexes and filled in for the publishing and accounting departments; I worked wherever I was needed.

This really worked for a while because I wasn't the head of any department, so I had much less responsibility. In other words, this job did not go home with me. It was definitely more difficult juggling time, but I found time to paint on weekends, holidays and some early mornings.

Just like when working at Disney, I had an occasional commissions or sales. I also continued to subscribe to and buy art magazines for research. I generally looked for

exhibition possibilities, including juried shows to enter and art tips of any kind. Other times, it was just encouraging to read about what other artists were doing, especially the successful ones.

Art Marketing Tips:

14. We all need encouragement and the ability to self-motivate. We now have the endless possibilities of the internet. I had to subscribe to art magazines and trade magazine, including Art Business News, Art World News and Decor. You can now go online and find some of the trade magazines and numerous other websites for visual artists, including free websites.
15. Don't overlook listed opportunities to participate in juried shows nationally and internationally. First, however, do some research on the gallery, museum or venue before making any decision to work with them.

CHAPTER TWELVE
Flipper's

Shelter's owner, Denny Cordell, soon partnered with his friend, nicknamed Flipper, and opened a private roller skating rink in the heart of West Hollywood. It was on the corner of La Cienega and Santa Monica Boulevards and geared to entice an exclusive show business clientele.

I accepted the offer to help manage the offices which were across the street from the rink. Along with my role as receptionist, I handled some membership duties and the ever-popular guest list. We had an incredible opening and soon Flipper's became one of the hottest clubs in the city.

Professional skaters from New York City were hired to perform for our clientele and they also gave our members private and group skating lessons. We even had specially catered Cajun food on our menus and a full bar.

For our celebrity membership, we had private booths available and the hottest deejays in the business. We had a very eclectic and elite group of members which included everyone from actor Robin Williams to singer Lou Rawls.

A mural inspired by the French artist, Henri Rousseau, covered an entire wall of the skating rink, depicting a jungle scene with animals peering out at you while you skated. I wished I could have been one of the artists that helped to paint that magnificent piece of art.

Now you may ask: What art marketing tips could she have learned from her experiences working at Flipper's?

Art Marketing Tips:

16. Our invitations for memberships were hand delivered to the offices or homes of the upper echelon. A calligraphist hand painted the invitations on exquisite scrolls of parchment and then rolled and tied them with bright colorful ribbons. From managing this process, I learned that a creatively alluring invitation most certainly will yield a much more positive response and audience, which of course, can be done on a much smaller budget.

17. When you invite collectors or potential collectors to visit your studio or gallery, make them feel at home and very welcome. Have a variety of hot and cold drinks to offer, including wine. In addition, provide some simple snacks, including cheese and crackers, mixed nuts and cookies.

18. Know that the more comfortable your clients feel, the more receptive they will be to buying or commissioning a work of art.

19. Realize that your artwork will be the "a la Rousseau mural" by giving potential collectors the treat of sharing the inspirations for each one of your artworks on display plus seeing your actual painting space.

CHAPTER THIRTEEN
A Roller Coaster Ride

My time at Flipper's was short but very motivating. From there, I went back to work for Shelter Records, working on temporary job assignments and I paid my expenses from the sales of some artwork, painting commissions and some publicity writing assignments.

One morning, I set out in search of a gallery that would exhibit and sell my work. I rented a car for the day and loaded it with several of my paintings. It was a sunny day in Los Angeles and I was ready and eager to hit the road.

I know that I did some research on the galleries I decided to visit otherwise I wouldn't have known where they were located. I don't know where I got the notion that I could just make pop calls on the proprietors of these galleries.

My first stop was the gallery in the Aaron Brothers Art Store in Hollywood. I went in and asked to speak to the person in charge of the gallery section. I waited for just a couple of minutes then a kind gentleman who was very willing to look at my paintings appeared.

During that time, I was working on my series of wild and domestic animals. My paintings were somewhat impressionistic in the application of the oil paints. The eyes of the animals were very realistic and penetrating, a technique taught to me by another self-taught artist, Prophet Jennings.

The Aaron Brothers gentleman liked my paintings, which made me feel truly wonderful, and he took the time to explain to me how the paintings in the gallery were painted. They were imported from various foreign countries where the artisans painted in an assembly line fashion.

He further explained that the wholesale prices for these paintings were minimal, creating a huge profit margin when they were framed and sold in his gallery. By sharing this information with me, he was also telling me why my paintings wouldn't produce nearly the same profit margins.

My paintings would, of course, be sold to them at a substantially higher wholesale price, creating a much higher retail price. This, however, would defeat their whole marketing strategy.

I learned a lot in that relatively short visit. I left feeling a little disappointed but creatively charged. Nothing could have prepared me for the reaction I would receive from the next gallery on my list.

I was all smiles as I entered a gallery in West Hollywood carrying a couple of paintings. The proprietor took a very brief look at me and then at my paintings and said with great attitude, "My gallery only carries fine art." He then dismissed me from his premises, with barely a nod and definitely without a smile.

This man had just rudely told me that my artwork wasn't good enough for his gallery and I felt hurt and on the downward slope of my roller coaster ride. However, I didn't let him deter me from visiting the last gallery on my list that day.

The gallery was the Fowler Gallery in Santa Monica near California's coastline. I approached this gallery smiling pensively. My smile had no resemblance to the smile I was wearing when I left Aaron Brothers.

When I entered the gallery and introduced myself to John Fowler, he genuinely welcomed me and my paintings. In words that lifted my spirits and completely diminished the downward slope of my roller coaster ride, he said, "Your paintings are too good for my gallery, but I'd love to have the opportunity to exhibit them."

Art Marketing Tips:

20. Realize that on a creative level, your art is your art. Never let someone's opinion dampen your spirit or change your focus or direction.
21. On the professional side, research is essential. Before even considering contacting a gallery, find out what kind of artwork they exhibit and what artists they represent. Then inquire about what their policies are for reviewing art. You can find out a lot by visiting their website for the answers. I don't suggest calling them by phone, a letter of introduction or inquiry would be better. Be sure to include your business card or a postcard that have samples of your artworks on them.

22. Never visit a gallery with the intention of showing your artwork or portfolio without a prearranged appointment. To do so would be very unprofessional and downright rude.

CHAPTER FOURTEEN
Paris, France

I continued to participate in some exhibits, primarily group, along with a few juried exhibitions. I was still painting wild and domestic animals when I sent slides for consideration to a juried show being held in a small gallery in New York City. The owner loved my animals, so my work was included in the exhibit.

After receiving an honorary award, I was asked if I'd be interested in exhibiting in a group show in Paris, France. Unfortunately, it was impossible for me to participate at that time. There was an entry fee and the expense of shipping my paintings to and from Paris; I didn't have the funds for either.

The following year, I received my second Prix de Paris award from the same gallery and I was then able to pay the fee and the shipping expense. I booked passage to the city I had so longed to visit since viewing in my early teens the original version of the film, *Moulin Rouge*, starring Jose Ferrer as Henri de Toulouse-Lautrec.

The museum was the Musee de les Duncans and the proprietor, who lived seasonally between the two cities of Paris and Manhattan, was the niece of the famous dancer, Isadora Duncan.

Our exhibition included an eclectic group of artists from several countries. This was May 1980. With great anticipation, the publicist in me decided to send a

press release to my local newspaper, the Los Feliz News. They responded favorably and I received my first press coverage for an exhibition. The story included a small photograph of me and a photograph of one of my cat paintings titled *"**Black Bottom**"*. I made a point of asking them to place the emphasis on the painting by printing it larger and to my delight, they did.

Art Marketing Tips:

23. Press clippings are great art marketing tools. Writing and submitting one for your self is quite acceptable.
24. Make a list of your neighborhood and local newspapers to keep on hand for easy reference of national and international art publications that may be interested in your story. You can find these lists through research on the internet.
25. Even if you're exhibiting with a gallery or museum, it is good to find out how the press is being handled. You may be able to entice more press coverage. Remember to cover as many bases as possible; you never know what interest you might spark.

CHAPTER FIFTEEN
Tour of France

I traveled to Paris, France, on May 13, 1980, and I enjoyed the entire experience, which was only heightened by the fact that some of my paintings were part of an exhibition on the Left Bank of Paris, the famous artists' district.

While there, I designed my own tour of France. Of course, the famous cabaret the Moulin Rouge was on the top of my list and I enjoyed a wonderful and outrageous evening of entertainment there.

I took a bus trip to Epernay, the wine country, and visited the cellars of Moet Champagne. I not only learned the entire process of making champagne, I also learned that one of the main ingredients in Dijon mustard is the fermented residue from champagne.

I took a train to the South of France and made stops in Arles looking for signs of Vincent van Gogh and Paul Gauguin, Aix en Provence for the lavender fields and the warm climate, Saint Tropez to visit Cezanne's studio high up on a hill and to Marseilles for their famous Bouillabaisse, which I first sampled at a small restaurant by the sea.

I took so many photos and collected postcards from the different regions I visited so I could capture most of what I saw in my paintings when I returned home. I also took a bus to The Palace of Versailles, the amazing royal chateau and grounds where King Louis XVI and Marie-Antoinette reigned and lived until the French Revolution. It is now an

internationally famous museum.

Upon my return home, I thought of myself as the "Josephine Baker of Art." I was confident that my exhibitions in Paris would impress everyone I told or who would read about it. I also received my first international art review in a Parisian newspaper and it was very favorable. However, there was still a lot more to be done before people would really begin to really take notice of my art.

Art Marketing Tip:

26. All experiences are useful in marketing art. For instance, many people were thrilled with the paintings that my trip inspired because they knew that I had actually visited the places. In a sense, they had traveled vicariously with me through my paintings.

CHAPTER SIXTEEN
Micro-Z

When I returned home from France, I had to begin a "regular" job search again and I found employment at Micro-Z Corporation. Micro-Z was a computer software company where I learned accounting by computer, using their software. Within a month, I was handling all accounts receivable, accounts payable, payroll and payroll taxes for their three offices in Los Angeles, Seattle and Las Vegas.

When I interviewed for the job, I was so full from my experiences in France, that I couldn't help but share some of my excitement. In fact, I was wearing a Saint Tropez shirt and white slacks.

The first person I met that day was Tylene Osborn. She was the personal assistant to the President and CEO. She would become my champion throughout the 18 months I spent as an employee of the company.

Yes, I was indeed an artist in need of a regular job, but I had very high hopes for my artistic future. I began my regiment of getting up at 4 a.m. to paint a couple of hours before going to work. I also arranged to work earlier hours. I worked from 7:30 a.m. to 3:30 or 4 p.m., Monday through Friday.

This gave me concentrated quiet time in the morning, since all the other employees usually worked from 9 a.m. to 5 p.m. I was also able to beat most rush hour traffic on my way back home.

Sunday through Thursday nights I was usually sleep by 8 p.m. I ran my errands on Saturday mornings and then cleaned my apartment. This schedule gave me the luxury of painting all day on Sundays.

Art Marketing Tips:

27. Maintaining good time management skills is one of the most important factors of success. Create a schedule that works for you.
28. Remaining focused on your goals is essential.

CHAPTER SEVENTEEN
La Shanda

I received my first painting commission from Ty very shortly after I began working at Micro-Z. She commissioned me to paint a portrait of her granddaughter. Now remember, I'm a self-taught artist and until that day, I had never been commissioned to paint a portrait. I decided to challenge myself.

Ty gave me several photographs of La Shanda to work from. I chose a photo of her sitting on the kitchen floor. She was about 11-months-old and she was holding something in her hand, looking at the object very intently.

The morning before I started the painting, I went for a walk primarily to think about how I was going to paint this beautiful little blond and blue-eyed baby girl while hoping to release the anxiety I was feeling. When I came across a small yellow wildflower growing in the grass, something immediately clicked in my mind. I picked that flower and took it home with me. It became the focus of her attention in the painting and the kitchen floor was transformed into grass.

I was then ready to begin the painting. The surprising outcome for me was that I had totally captured La Shanda in the painting and Ty loved it. I'm certain that my experience painting animals paid off in many ways, especially when it came to painting eyes realistically. Ty commissioned me to paint La Shanda again, this time seated between her grandparents on their living room couch. A commission to paint Ty followed and my last

commission from her was to paint the president of Micro-Z as a surprise gift to him.

Art Marketing Tips:

29. I can't overemphasize how important it is to let people know that you're an artist. The possible positive outcomes are limitless.
30. Never make a nuisance of yourself by pushing your art at your job. You will more than likely completely turn people off and possibly lose your job.

CHAPTER EIGHTEEN
Bunker Hills Art League

In 1980, I also heard about an artist group that was forming in Los Angeles. It was called the Bunker Hills Art League and it was the brainchild of artist, Barbara Wesson. I was the first artist to arrive at the initial meeting. I was early.

There were about 20 artists who attended that first meeting where Barbara shared her mission and goals. Brief introductions of the artists followed, and some plans were made. Some of the other artists that would become members of Bunker Hills Art League were Varnette Honeywood, Charles Bibbs and Adrian Wong Shue - all who went on to illustrious careers.

Learning art marketing skills was our primary focus and new and established artists were all welcome to join free of charge. Barbara also created exhibition opportunities for our group. We were really learning and selling our art at the same time.

Our first guest speaker was Ernie Barnes, who spoke about how he made a place for his art in the world. From him, I learned how proactive artists really need to be if they want to be successful. Waiting for someone to discover you was simply out of the question.

After a time, when time didn't permit me to attend the meetings, I continued my association by sharing information. I'd either send it by mail or call it in to Barbara. We all benefited and shared. In fact, we were able to do this very successfully through our group's newsletters.

Art Marketing Tip:
31. Become part of or establish a small group of artists and share information and exhibition opportunities. I know you'll find quite a few visual art groups online.

CHAPTER NINETEEN
Municipal Art Gallery

I always looked for exhibition opportunities and have managed to include my work in other group shows. One was at the Municipal Art Gallery in Los Angeles. I only had one painting in the show, but it was still worthy of adding to my resume.

I was then inspired to write Mayor Tom Bradley's office and request an appointment with the curator of the Municipal Art Gallery. My purpose was to increase the number of my paintings exhibited in future shows. An appointment was made and Micro-Z gave me that morning off.

I arrived at the gallery early with several original paintings to show. The paintings were from my wild and domestic animal's series. Unfortunately, the curator was very rude. She walked in the front door and made a point of coming through her office, behind the wall where my paintings were displayed. So it was impossible for her to see any of them.

Then she merely gave my paintings a thirty-second glance before making her comments, "You need to paint like so and so…You need to go back to school...You paint only to make people happy." Finally, when I very politely told her about my art sales record, she said, "When you get your Cadillac, come back and take me to lunch." This appointment didn't even last ten minutes.

Now, of course, my feelings were very hurt. I was stunned and very disappointed. I was also embarrassed when coworkers asked how the appointment went because I knew how excited they had been for me and I hated disappointing them.

In retrospect, I should have reported the curator to the mayor's office, but I didn't. I can only imagine what harmful effects she has had on other artists, perhaps even on their careers. I'm very thankful I didn't allow her to ruin anything for me. I got over the hurt feelings and can only look back and say that she must have been a very miserable person.

Art Marketing Tip:

32. Don't take the rude behavior of others personally. You will encounter all kinds of people during your life and career; some will be very positive and unfortunately, some will be negative.

CHAPTER TWENTY
The Tax Business

While still working for Micro-Z, I executed a plan and made it work for me. In the 1980s, you could choose an exempt status for withholding taxes on your paychecks. I decided that I would save the money that would have generally been taken out of my checks for taxes in a bank account. With this money I planned to take a leave of absence from my job. With Ty's assistance, this worked out.

I can't remember exactly how much time I managed, but I'm sure I combined it with some vacation time. I'd say I gave myself about 4 weeks of uninterrupted painting. Heavenly!

When It was time to go back to work, I was transferred to the new office in Monrovia, California. I was promoted to the position of supervisor of the accounting department. This was most certainly a more difficult job for me. Along with supervising my staff, I had the added responsibility of training them to do their accounting jobs on computers with Micro-Z's software.

What was so great about my previous job in the Los Angeles office was that I generally worked quietly alone. While I still got up early and painted before I went to work, the new responsibilities made my job much more draining. As supervisor, I also handled petty problems between the employees; it was like babysitting adults. After three months in my new office, I realized I needed to get on with my life.

Fortunately, I had my savings and the relocation money Micro-Z paid, so I was off to a good financial start. While working at Micro-Z, I also learned about payroll taxes. I prepared all the government tax reporting forms, the W2s and 1099s for the employees.

My next stage of evolution made perfect sense; I decided to start my own income tax business for individuals.

Art Marketing Tip:

33. We have to keep reinventing ourselves, to some degree, throughout our lives and careers. In this case, it meant that I needed to find another way to generate income to remain creative.

CHAPTER TWENTY-ONE
Southern Living Magazine

My income was now derived from occasional art sales and commissions, freelance writing and my new tax clients. Since I hadn't yet taken any courses in tax preparation, I charged my clients ten percent of their tax refund amount. Not a bad arrangement, since I only took on clients that would receive refunds.

I managed to work freelance for almost a year before looking for temporary but steady employment and this time, the criteria went back to finding a job with much less responsibility. I found that job when I was hired by Bob McLean to become the office manager for Southern Living Magazine and Decorating & Craft Ideas' West Coast advertising office.

I learned a lot about the ins and outs of magazine display advertising. In the record business, I learned how to promote recording artists and with Southern Living, I learned all aspects of promoting and selling magazine advertising space.

My job was relatively simple since we were a 3 person office and we all had other passions in life; it was about getting our work done, then on to our individual lives. That was why we worked so well together.

I answered the phones (but we also had a telephone answering service backing me up), signed for packages, sorted through the mail, answered and typed some

correspondence for the guys and put together advertising media kits.

Bob and Greg did research on possible advertising clients, made phone call pitches, set up their individual appointments, attended some conferences, and wined and dined their clients at various restaurants.

They allowed me to do my art research and mailings, make my business phone calls and whenever possible, they would give me Fridays off or send me home early.

Art Marketing Tips:

34. Again, I was able to learn new skills that would be easily applied to marketing my artwork: putting together a professional package/media kit.
35. I learned the importance of having business cards, personalized stationery and a good general presentation to maximize interest in my artwork and sales.
36. I changed the signature at the end of my correspondence from "sincerely" to "cordially," following the example of Bob's pitch letters to clients.

CHAPTER TWENTY-TWO
"Perkie"

While working at my new job, I took the H&R Block Income Tax Course. I completed ninety percent of my homework at the office. I opted to take the full day extensive course on Sundays instead of evening classes.

My instructor, Perkie, made the dull tax information almost exciting. Her way of teaching was often filled with rhymes and jokes. You could tell that she really enjoyed teaching.

When I first enrolled, I just wanted to pass with an average grade and get my certificate. But she got me so involved that even though my first test score was in the 70s, by mid-term I received a grade of one-hundred percent on my exam. I even had the nerve to be upset that my ending course grade, which was an A, stood only for my ninety-three percent grade average.

Am I an overachiever, or what? I believe there are certain people in life that can just bring out the very best in you and Perkie did that with me.

I was offered a job immediately with H&R Block. However, I knew that I'd make much more money on my own. Perkie gave me her home phone number so that I could call her if I needed any help with my clients. I called her often during my first couple of years as a tax preparer.

Perkie also surprised me when she told me that she had taken up a collection from the other employees at her H&R Block office to commission me to paint something for their supervisor as a surprise gift. I painted a very colorful seascape, and as planned, unveiled it for all at their office party.

Art Marketing Tip:

37. Again, I'm emphasizing the importance of letting people know you're an artist. If Perkie didn't know, I would have never received the commission.

CHAPTER TWENTY-THREE
Accounting Arts

Even though, I already had some tax clients, getting my certification enabled me to take on many new clients with much greater confidence. I even advertised my tax business in The Artist's Magazine. I only received one client from the ad, but he ended up designing my first tear sheets.

I named my tax business Accounting Arts and my business lasted for almost 10 years. During those years, my clients included visual artists, performing, artists, writers, directors, doctors, lawyers, a stallion breeder and farmer and members of the general workforce. Some of my clients sent me their taxes to prepare from other states.

I thought my tax business would be seasonal. But I found out that my clients would call me throughout the year with tax-related problems. I also realized that I needed to supplement the income from my business with temporary accounting assignments, so I registered with a temporary job agency.

Of course, I was still painting, exhibiting and selling my art, but much less so during the months of January through April. During those years, I started hosting home/studio shows to sell my art and found that venue to be one of the most financially rewarding.

Art Marketing Tips:

38. Host home/studio shows and invite collectors and future collectors.

39. Look for other non-traditional venues to show and sell your work.

CHAPTER TWENTY-FOUR
Signature Style

I managed to find good travel deals in the early eighties. In what would become a major turning point in my career, I visited Martinique. Martinique is an island in the French West Indies. The beauty of the island, the incredible sea and all the gorgeous people sparked a new style of painting.

The crowded marketplaces I experienced created an artistic challenge. Could I paint people without facial features and still capture their feelings, age and all the energies surrounding them? Could body language, posture and stance tell it all? That's when I began painting featureless people and that is what I'm recognized most for now - my signature style.

I experimented and fine-tuned this style in my *Cultures of the World Series*. It included paintings of Tahiti, Tibet, Africa, Brazil, Bali, Asia, Fiji, North American Indian tribes, African American heritages - including the Black Indian - and peoples of Caribbean Islands.

Art Marketing Tip:

40. Find and or create your signature style or styles. It will become your trademark and art collectors and enthusiasts will recognize your art on sight.

CHAPTER TWENTY-FIVE
Richard Pryor

Richard Pryor was an early collector of my art from my *Cultures of the World Series*. My paintings were privately presented to him by an art representative and his interior designer. From all the paintings shown, Richard purchased five of my original oils for what was then his new home in Bel Air, California.

It was an incredible to add his name to my celebrity list of collectors which already included actors Glynn Turman, Roger E. Mosley and Art Evans. Richard Pryor's acquisition made the news in a couple of Los Angeles newspapers and many people spread the word, generating even greater publicity for me.

One of the paintings he purchased was titled *"Purification"*. It's a 36-inches by 48-inches oil on canvas painting of an island purification scene in Bali. It was later published by Essence Art as an open edition print and it sold very well. I was also able to license it for a book cover, a magazine ad and even a line of clocks.

Art Marketing Tips:

41. We're back to the bandwagon effect: Richard Pryor's purchase made others think, *If Richard Pryor purchased five of her paintings her art is definitely worth collecting*.
42. Before selling an original painting, be sure that you have a high-resolution digital file, a tiff and a jpeg scanned.
43. Keep your copyright.

CHAPTER TWENTY-SIX
Brooklyn, New York

My most successful exhibition, to that date, was in 1988 in Brooklyn, New York. The exhibit was given by Ann Wheeler, my east coast representative at the time, in her brownstone. Paintings were on exhibit from my *Cultures of the World Series* with an emphasis on my series on the Black Indian.

Before the private Friday evening preview, actor Carl Gordon purchased the largest painting in the show titled *"Stilt Dancers"*, measuring 36-inches by 48-inches, and I was able to add his name to my growing list of celebrity collectors.

Ann created a festive yet relaxed ambiance. Friday evening was the private VIP showcase, followed by afternoon receptions on Saturday and Sunday. We sold very well and she paid me in cash, which I wired to my bank account in California.

Art Marketing Tips:

44. Make your clients feel relaxed and welcome. Never push sales.
45. Make sure to take care of your financial business. Always have a signed letter of agreement or contract with everyone that you allow to exhibit your artwork.

CHAPTER TWENTY-SEVEN
Self-Publishing

Just a few years before I signed with my first fine art publisher, Essence Art, I self-published four prints. Three were with an investor, Mohammed Waheed, who worked at my local post office.

Long before my Kwanzaa stamp was released, I was a post office junky. That's where I still faithfully go, Monday through Saturday, to pick up my mail and to mail correspondence. There are even some Sundays when I go by just to drop off my mail for Monday pick up.

I've had my same post office box number for about thirty-eight years. Mohammed shared some wonderful photographs he'd taken while visiting the Comorian Islands, which are off the coast of Mozambique in Africa. At least ten of my oil paintings were based upon and inspired by his photography.

The first two paintings were based upon events preceding an actual wedding ceremony. The first, ***"Comorian Wedding Moja"*** captured the guests entering the wedding venue. The second, ***"Comorian Wedding Mbili",*** depicts the "Well Wish Ceremony" for the bride to be.

We both loved the results, so we decided to invest in printing the pair as my first limited edition prints. I had them printed by a company called Color Q. The edition sizes were two hundred signed and numbered offset lithographs, which sold out in little time.

To eliminate excessive bookkeeping, we simply split the edition in half, one hundred each. We settled on the retail price, which began at $65 and within two months, the last prints in both series sold for $350.

With the success and profit made from the first two editions, we invested in a third painting, ***"Enlightenment"***, depicting a solitary man reading the Koran in a mosque with just a little light coming in from a small window. Again, we split two hundred prints, selling our inventory individually. Mohammed sold most of his prints at retail and while I sold the majority at retail, I also began selling my prints to galleries at wholesale prices.

The first gallery to carry my prints was Samuel's Gallery in Jack London Square, Oakland, California.

Art Marketing Tips:

46. It is very important for you to have a permanent mailing address and a telephone number where people can always contact you. I've always used my post office box address and I've always made use of an outside answering service for my business and advertising purposes.
47. There are several ways that you can get your art published as reproductions, investors are just one of them.
48. You can also invest in yourself by using the money made from selling an original to self-publish it in a limited or open edition reproduction.

CHAPTER TWENTY-EIGHT
Waiting to Exhale

Samuel's Gallery owner, Samuel Fredericks, gave me my first break selling prints in a gallery. He was willing to invest by purchasing my work wholesale and showcasing it in his gallery. I learned most of the ins and outs of the gallery business through him Samuel, including how to package and ship artwork correctly.

Over the years, he has given me several exhibitions. He also truly promoted my work at a time when my name was not widely known in the art world. As artists, we not only need to believe in ourselves, but we need our support groups, our champions and friends. Sam is one of my special champions.

In the early 1990s, Terry McMillan discovered my work at Samuel's Gallery and in a matter of a couple of years, the print *"Ensemble"* she purchased from him would become the cover of her international bestselling book, *Waiting to Exhale,* translated into several languages.

She received my contact information from Sam and she called and asked if it was possible to use *"Ensemble"* on her cover and of course, I said, "YES!" Her book publisher called me to make the financial arrangements.

Art Marketing Tip:

49. We all have champions: they may be family, friends or business acquaintances. Also establish and cherish your other possible support groups and be open to learn from

all. Mentors come in a variety of packages.

CHAPTER TWENTY-NINE
The House of Seagram

For years, The House of Seagram commissioned African American artists to create personal statements about the culture and heritage of the African American family. I am truly honored to have been one of the artists in that series.

My fellow artists were James Denmark, Hughie Lee-Smith, Louis Delsarte, Elizabeth Catlett, Jonathan Green, Geoffrey Holder and Gordon Parks. I was the first woman.

Each image created by these renowned artists was published as a limited edition of 100 original lithographs. All were hand signed and numbered in pencil by the artists. They were then donated to the National Urban League to be sold at $1,000 each to raise funds for this wonderful nonprofit organization.

Now, why was my artwork considered for such a prestigious project? Good question. I donated a limited edition print to United Negro College Fund as a silent auction item to help raise monies for Historically Black Colleges and Universities. The gentleman who purchased my print at the event, Mel Owens, got in touch with me and asked me to send him more information on my art.

I later found out that he worked for the House of Seagram and that he suggested that I be considered for the next year's commission for Black History Month. He sent my

information directly to their New York Office. So, my silent auction donation opened the door to my first corporate commission.

Art Marketing Tip:

50. Never underestimate the power of giving. Donate your artwork to worthy causes. Remember, it's not necessary to donate originals; art reproductions are more than welcome. Just imagine the possible exposure your artwork could receive.

CHAPTER THIRTY
With Honors

Education was the theme chosen the year I received the Seagram commission. After some thought and research, I decided on a college graduation scene.

To create a unique scenario, I painted the graduates in white caps and gowns. The commencement ceremony took place outside under a beautiful blue sky. Several of the graduates' gowns are draped in colors representing the honors they received. I titled the painting *"With Honors"*.

I made sure that I kept full copyright to my painting and made certain that it couldn't be considered a "work for hire" in the commission contract I signed. To date, it's been reproduced as an open edition print that is still selling well, especially around June. I have also licensed the image for book covers, greeting cards and calendars. In the future, I may even release *"With Honors"* as a limited edition giclee on canvas.

Art Marketing Tip:

51. Read every single line of commission agreements and contracts. It's even better if you consult with someone in the legal profession or with an attorney. Maintaining your copyright is not only important but can be very lucrative when it comes to licensing your artwork later.

CHAPTER THIRTY-ONE
First Class

Seagram was my first corporate commission, my first experience of first class air travel and my first stay at a five-star hotel.

I traveled to New York for the event in February 1990 to sign and number the series and to unveil the original painting. In conjunction with the unveiling of *"With Honors"*, Seagram gave me an art exhibition that featured twenty-two of my original paintings.

The unveiling and exhibit reception took place at their corporate offices on Park Avenue. Cynthia Moore, who was then in charge of public relations, gave me a speech to read and I delivered it to the three hundred plus guests in attendance. Then *"With Honors"* was unveiled and after that formality, the reception began complete with food, drink and live jazz.

My art exhibition was then relocated to the National Urban League's offices in Manhattan for the remainder of Black History Month in 1990.

Art Marketing Tip:

52. It doesn't hurt to hone in on your speaking and people skills. I have found that the general public and your possible collectors really want to hear from you.

CHAPTER THIRTY-TWO
Alice Walker

When I first found out that the Seagram commission would also include an exhibition, my next step was selecting the paintings for the show. One of the paintings I chose was ***"A Tribute to Alice Walker"***. It was a painting inspired by one of her books, ***Temple of My Familiar***.

As a courtesy and with the desire to let her see what her book inspired, I sent her a photo of the painting. Although I didn't hear back from her immediately, I found out later that she had kept the photo.

Within a year, I received a call from her assistant, Joan Miura. Alice Walker asked about the possibility of using my painting for the cover of a trilogy of her work that Book of the Month Club was publishing.

The deal was made and - voila - my first book cover! During the conversation, I mentioned to Joan that I still owned the original painting and asked if she thought that Alice might be interested in purchasing it, and she was. As a result of my inquiry, I received my first book cover and was honored to add Alice Walker's name to my list of collectors.

Art Marketing Tip:

53. Fully use all opportunities. If I hadn't shared the fact that the painting was available for purchase, I may have never had the honor of adding Alice Walker's name to my list of collectors.

CHAPTER THIRTY-THREE
Essence Art

While still in New York, I had a meeting with Jan Persson. Jan owned Essence Art and he became my first fine art publisher and one of my collectors - all in the very same afternoon over lunch. Before that meeting, I read that Essence Art was looking for artists to publish. I sent Jan a package and shortly after we spoke by phone.

When the Seagram commission came through, he was one of the first guests I invited to the reception. We had the opportunity to meet and he had the chance to see my original paintings.

The first two open edition prints that he published were *"Ensemble"* (Terry McMillan's *Waiting to Exhale* book cover) and *"Purification"* (one of the originals in Richard Pryor's collection). These two prints sold extremely well and they continue to sell to this day.

I credit the release of the print *"Ensemble"* as part of the overall success I have had in the book publishing world. Ironically, Terry McMillan purchased this print from Samuel's Gallery and it hung in her home while she was completing *Exhale*.

It seemed that now momentum was really beginning to build. Almost as soon as I returned home to Los Angeles, I received a call from the Mark Taper Forum. The play *Miss Evers' Boys* was being mounted, and Dr. Beverly

Robinson, the dialect coach, chose me to create the poster art for the play. Dr. Beverly and I had a mutual friend, Carl Gordon, who you'll remember, is also a collector of my work.

Carl always kept some of my business cards and he had given her one. So, Dr. Beverly, armed only with my business card, got that commission for me. I had never even met her.

Art Marketing Tip:

54. Have business cards printed with your paintings or artwork on the card. People tend to hold on to these "mini prints."

CHAPTER THIRTY-FOUR
Miss Evers' Boys

After reading the play *Miss Evers' Boys* and parts of the book *Bad Blood*, I found myself seeking to create an image that conveyed this depressing but true story about the testing of syphilis on African American men. I also wanted the art to be pleasing to the eye.

I was amazed when I was later informed that the poster was so popular that it had sold out. The Mark Taper Forum kept only a few for their archives. The Mark Taper Forum's art department allowed me to purchase quite a few of the posters at a discount and my signed copies sold equally well.

The icing on my cake was when Dr. Beverly Robinson purchased the original painting from me. I must have done my job well and for that reason, I felt fulfilled.

Art Marketing Tip:

55. It always pays to research your projects well, especially the commissioned ones. What may seem like minor details or facts are crucial to the authenticity of the end-product.

CHAPTER THIRTY-FIVE
Museum of African American Art

In 1992, I was approached by Al Dave, a board member of the Museum of African American Art in Los Angeles. He asked if I would be interested in having a solo exhibition at the museum. I definitely was.

This would be not only my first exhibition at a museum in the United States, but also my first art retrospective. Later, I would have the opportunity to meet the other members of the board that included Harvey Lehman, Allen Webster, Jr., Berlinda Fontenot-Jamerson and William Simms.

The artwork in the exhibition included paintings from my wild and domestic animal series, which were painted between 1977 and 1980. This exhibition included pieces that were originally shown in my exhibition in Paris, France, and pieces from my *Cultures of the World Series*. There were 45 original paintings in all.

This exhibit must have been predestined to travel because another board member, William Simms, suggested the Afro-American Cultural Center in Charlotte, North Carolina. So, in February 1993, I received my second first class treatment. This exhibition was sponsored by Transamerica Life Companies.

While in Charlotte, I spoke at four schools and a children's center. In addition, I was interviewed for several newspaper articles and two cable television programs and attended receptions and signings at the museum. The days started early and ended late. Every night, a different

person hosted a formal dinner for me either in their home or at a restaurant.

After five days at this pace, I was so exhausted that I slept all the way home on the plane, missing all the special first-class treatment. I renamed Charlotte "Hush Hush" after the old Bette Davis classic film ***Hush...Hush, Sweet Charlotte***. It was the personal joke I shared with my Godmother, Willie, and my personal assistant, Tonda, who were with me through the entire incredible experience.

I learned that there is much more expected of an artist than I had ever realized. In my dreams, I had visions of living in some faraway exotic place like the South of France or Tahiti, painting uninterrupted. In those fantasies, I would only attend my art exhibitions once every two to three years, but all my paintings would sell out - even at the exhibitions that I didn't attend.

I never imagined that good public relations skills would be a necessity if you truly wanted to have a successful art career. I often wondered why people needed to see me and hear me speak.

Art Marketing Tips:

56. Talent is not the only ingredient necessary in becoming a successful artist.
57. Consider taking a public speaking or acting class if you think it will help you feel more relaxed in front of an audience, interviewer or at your art receptions.

CHAPTER THIRTY-SIX
Book Covers

About a year later, I received a call from Terry McMillan. She asked me about the possibility of using *"Ensemble"* on the cover of her soon to be released book, *Waiting to Exhale.* Between Alice Walker and Terry McMillan, there couldn't have been a greater introduction into the world of book publishing.

Alice's publisher, Book of the Month Club, had a small but steady audience, so it was a great start for me. However, *Waiting to Exhale* introduced my art to the international publishing world. My cover art was then licensed from me by the United Kingdom, Spain, Germany, France, Japan and Finland.

When time came for the release of *Waiting to Exhale,* the mass-market book publisher, Pocket Books, licensed the use of my cover art and commissioned me to create two new covers. One was for the rerelease of *Mama* and the other for the rerelease of *Disappearing Acts* in a mass-market format. The companies for the release of the trade book, the audio book and the computer book for *Waiting to Exhale* all licensed my cover art.

Japan's Shinjuku-Ku was my most loyal publishing house. The president of the company purchased an original oil painting from me and when *How Stella Got Her Groove Back* was to be translated and released in Japan, they came back to me for the cover art. The original American cover art was based on a photograph.

Right after the initial success of *Waiting to Exhale*, I put together a mailing to publishing house art directors. I included a photocopy of the book cover, samples of other artwork, bio, business card and letter of interest. This was the way the industry discovered that I was available and interested in creating more book covers.

Art Marketing Tips:

58. Let people know that you're available for the various jobs you may be interested in.
59. When you're hot, keep the fires burning. Make the best possible use of all your successes.

CHAPTER THIRTY-SEVEN
Acts of Faith

Next came what would be considered a parade of brilliant authors, beginning with Iyanla Vanzant. I received a call from her publisher, Simon & Schuster. They were looking for cover art for her book, *Acts of Faith*, and they chose my painting, *"Visions"*.

This was phenomenal because within a three-year period, my artwork was gracing the covers of three of the most popular bestselling female authors.

After the incredible success of *Acts of Faith*, Simon & Schuster licensed *"Visions"* as cover art for calendars, and then again for a special hardbound printing of *Acts of Faith* titled *The Big Book of Faith*. They later licensed the use of another one of my paintings, *"Sacred Bath"*, for another Vanzant book, *Faith in the Valley*.

My art would eventually be used as cover art for books by Julia A. Boyd, Connie Briscoe, Linda Hollies, Buchi Emecheta and a multitude of other creative and inspiring authors. To date, my art graces the covers of over 70 books, which still amazes me.

Art Marketing Tip:

60. Self-publishing is now bigger than ever. I've created book covers for self-published authors, including Barbara A. Perkins, Khaleedah Mohammad, and Marcia Dyson. Self-publishing is another market to tap.

CHAPTER THIRTY-EIGHT
Children's Picture Books

As a direct result of the success of **Waiting to Exhale**, I was asked by a marketing person at Penguin Putnam Books if I had ever thought of illustrating children's picture books. (I wish I could remember her name, because her inquiry opened many new doors for me.) Well, I hadn't but she said that my bright colors would lend themselves well to children's picture books and I was very interested in what would be a new art form for me.

She introduced me to Cindy Kane, who was a senior editor at Dial Books for Young Readers. After we talked, Cindy faxed me the manuscript for **Snow on Snow on Snow**, written by Cheryl Chapman. I loved the manuscript and the challenge, so Dial's legal department prepared a contract defining advances, deadlines and other issues that were agreed upon.

Art Marketing Tips:

61. Don't forget the business of art. Have your attorney or legal consultant go over the details of all contracts before agreeing to a verbal or written contract. Your primary concern should be keeping the copyright to your artwork and to the text if you've written any of the books.
62. Be open to all artistic possibilities. Don't limit your creative self.

CHAPTER THIRTY-NINE
Tukama Tootles the Flute

Right after being offered my first picture book, I did some research on children's book publishers and created another mailing. I'm a firm believer in research and follow up. I was very surprised when I received several responses.

In fact, before I was contracted to begin work on *Snow on Snow on Snow,* I received an offer from Richard Jackson who at that time, had his own imprint with Orchard Books. This book was titled *Tukama Tootles the Flute* and it was written by Phillis Gershator. *Tukama Tootles the Flute* must have been destined to be my first children's picture book and Richard Jackson destined to be my first editor, my mentor and the "father" who introduced me to the world of children's books.

Tukama was about a reckless little boy on a Caribbean island who spent his days lazily walking around the island playing his flute. He wouldn't help his grandmother with the chores and he often came home late, but he learns his lesson when he is caught by a two-headed giant.

Richard simplified this new creative process for me. He explained the entire process and demonstrated it to me step by step, from creating publishing book dummies to incorporating the actual finished paintings. He was also a great editor. He allowed me my full creative freedom, but he was there if I needed him.

When this first project was completed, I started work on my second book, *Snow on Snow on Snow.*

At first, the process was very disappointing. After working one-on-one with Richard, the process felt more like art by committee because I wasn't working with just my editor anymore, but with a committee of people in the art department who most often gave demands, not suggestions.

Cindy Kane, my editor, did save the day when I contacted her to tell her about my frustrations. First and foremost, the committee wanted me to add facial features to my characters.

They then wanted to change a page in the book where I had put a small table beside his bed and books, one partially open to show that he not only played games, he also read books. This was a wonderful subliminal suggestion for the children who would be read to or who would read this book.

In place of the table of books, the committee suggested a window looking out on the snow - an image that already filled many pages of the book.

Again, research paid off. I reminded them of a book published by Penguin Books years ago, in the late sixties, that were still selling, *A Snowy Day* by Ezra Keats, which happened to have some characters without features. I also found a page advertisement from an international art trade magazine advertising fine art reproductions by a very successful artist, who if my memory serves me correctly, painted Amish children.

My research and the support from my editor Cindy, helped me do battle and win. The paintings were created in my signature style and my character kept the books beside his bed. *Snow on Snow on Snow* was a huge success; it was later released as a Big Book (same as a 32-page picture book format only produced at about twice the size) and was translated into Spanish.

Before I finished illustrating *Snow on Snow on Snow,* I was contacted by Albert Whitman & Company. They offered me my first opportunity to write and illustrate a book about the Kwanzaa holiday. On this project, I became THE author and it felt truly marvelous!

I again had a wonderful new editor, Abby Levine, who taught me more new ropes and *The Gifts of Kwanzaa* was created. So, in 1994, *Snow on Snow on Snow, Tukama Tootles the Flute* and *The Gifts of Kwanzaa* were all released and I was officially published by three publishers. Amazing!!!

Art Marketing Tips:
63. Research other possible art markets for your work.
64. Generate mailings and work will find you.
65. Don't overBOOK yourself. I learned that 3 books in one year is over tasking yourself and therefore, very stressful. There are generally eighteen to thirty paintings per picture book. What was I thinking? I didn't know.

CHAPTER FORTY
Greeting Cards

Before writing and creating paintings for my book *The Gifts of Kwanzaa,* I created a line of Kwanzaa greeting cards for a small greeting card company. I knew very little about the Kwanzaa holiday, so I did extensive research. At that time there were very few cards available for the holiday so my cards sold extremely well.

Even Hallmark stores carried my cards for a time. Over the next couple of years, I designed cards for all occasions for this greeting card company and I also wrote all the greetings. I even won the Greeting Card Association's Louie Award twice.

Unfortunately, this licensing deal soured because royalties were never paid on time or in full. I had to hire an attorney to terminate the licensing agreement. Before the termination of this agreement, I created 80 greeting cards. Which definitely brought my art and writing to the attention of the masses.

Through the exposure I received from the greeting card line coupled with the success of my book covers, my artwork became easily recognizable.

Art Marketing Tips:

66. Cover yourself well in all your licensing agreements. There may be times when you may need to terminate them.
67. Make sure to copyright all your work, including whatever you write in conjunction with an art project.

CHAPTER FORTY-ONE
"Ensemble"

The book, ***Waiting to Exhale,*** dramatically increased the sales of the open edition prints of ***"Ensemble"***, now also available as a mini-print, and increased the number of galleries that were carrying my artwork. It seemed that every Terry McMillan fan had to own at least one of the prints.

Before the film ***Waiting to Exhale*** was released, my licensed ***"Ensemble"*** products included magnets, boxes, T-shirts and watches. This is when BET SHOP on the Home Shopping Network contacted me.

One of my licensees was already selling my watches on BET SHOP and they were selling out in record time. As a result, I was asked if I'd be interested in appearing on the show, bringing more of my art related products and merchandise.

I contacted Jan at Essence Art and Ron at Dancing Frog Graphics for my licensed T-shirts. They were very interested, so I put them in direct contact with the producers of the show to discuss their individual requirements.

Because there is the issue of fulfillment with home shopping television shows, I worked out a deal with both licensees where they would completely handle

that aspect. This meant that they had to have their products packaged, bar coded and completely ready for shipment. In other words, let's say one thousand *"Ensemble"* prints constituted the number of prints the show wanted available. Each print had to be packaged separately in a mailing tube.

These tubes were then picked up and delivered to the network in St. Petersburg, Florida. As the orders came in by phone, the employees at the Home Shopping Network would address mailing labels and affix them to the tubes and ship them to the buyers.

I opted to just receive my usual royalty payments on all sales in lieu of managing what could have been an impossible task for one artist to handle, even with assistance.

One of the most successful air dates was just a couple of weeks before the opening of the movie *Waiting to Exhale*. I appeared on the television show and we sold out of the watches, T-shirts and prints.

Many of the women who purchased the watches and T-shirts wore them to the opening of the *Waiting to Exhale* in theaters around the nation. Some of them even went in "Sister" groups. The power of television is amazing!

Art Marketing Tips:

68. Licensing your art images can be very lucrative, so research the possibilities.

69. Try to attend at least one International Art Licensing Expo to get the feel of the magnitude of licensing opportunities available.

70. Subscribe online to License Magazine at www.licensemag.com to learn more about the market.

CHAPTER FORTY-TWO
Sunday

Now with the television appearances, published art, book covers, books and other licensed products, my art seemed to be virtually everywhere. Books then took on a life all their own and commissioned work continued to flow.

In 1995, I was asked to write another book for Albert Whitman & Company. My assignment was to write and illustrate a story about an African American family's typical Sunday.

My story was very idealistic. My family had a set of twin girls, happily married parents and living grandparents who were originally from the West Indies and a pet cat.

The story starts with sleeping late on Sunday, eating a favorite breakfast, dressing up, going to church together and meeting the grandparents there. Then it ends after dinner at the Grandparents house. I received a Parents' Choice Silver Honor for *Sunday* which was released in 1996.

Art Marketing Tip:

71. Develop a fitness routine to keep your mind and body healthy. This will also enhance your creative flow.

CHAPTER FORTY-THREE
Commissioned Paintings & More

In 1995, I completed commissioned paintings for the American Library Association, Essence Communications for Essence Magazine's 25th Anniversary, Maybelline & Kayser-Roth for their *Shades of You* line of cosmetics and nylons, Attorney Johnnie L. Cochran, Jr. and his wife Dale Mason and Dance Africa America for their 1996 and 1997 national dance tours.

I also illustrated two other books. The first was titled *How Mr. Monkey Saw the Whole World*, written by Walter Dean Myers and published by Doubleday Books for Young Readers. It was an animal trickster tale that I placed on a West Indian island. My wonderful editor at Doubleday, Mary Cash, would be my editor again on two other books for another publisher.

The second book was titled *Neeny Coming…Neeny Going*, written by Karen English and published by Troll/Bridgewater Books. This story takes place on the island of Daufuskie, off the coast of South Carolina. It's a story about two girl cousins and the effects of the changing Gullah lifestyle on the family. It was a thrill to receive a Coretta Scott King Honor Award for Illustration in 1997 for this book.

Art Marketing Tips:

72. Create a blog and share your good news.
73. Save all the press you receive from magazines and newspapers and scan them to create documents you can

email.

74. Update and list all your accomplishments in your biography.

CHAPTER FORTY-FOUR
Art in Embassies

The Art in Embassies Program of the U.S. Department of State is a wonderful program created in 1964 to showcase original artwork by American artists in the residences of United States Ambassadors worldwide. These residences serve as the centers for official state functions and the exhibited artworks are part of the Ambassador's mission at post.

I was very pleased to have been one of the artists added to this program in 1996. My artwork hung in the United States Embassies in Caracas, Venezuela, and Gagnoa, Ghana, for at least three years and one of my limited edition giclees on canvas was purchased by an art consulting firm for the American Embassy in the Ivory Coast of Africa.

Art Marketing Tip:

75. Submit your artwork to the Art in Embassies Program. It's easy to do and so much could come from it. It's a wonderful addition to your resume. Visit their website http://aiep.state.gov for submission guidelines.

CHAPTER FORTY-FIVE
The Kwanzaa Stamp

In 1996, I also received a telephone call from Derry Noyes, a designer who works with the United States Postal Service. She called to ask me if I'd be interested in designing a postal stamp for the Kwanzaa holiday. Of course, my answer was yes and the PR person in me immediately put together my media kit which I sent to her the next day via Express Mail.

Derry was quite impressed and asked me if I had time to design the stamp. I laughed and told her that I would make the time. I was to find out later that she'd only seen my artwork on a book cover I created for another author's book on Kwanzaa. Derry found the book when she was researching the Kwanzaa holiday on the internet and she received my phone number from the publisher.

Art Marketing Tips:

76. Make your contact information easily accessible. To keep my privacy, I always use my Post Office Box and an inexpensive outside phone service.
77. Creating a website is very important. If you can't afford to have one built right away, list yourself on other sites that feature artists. Many of these websites have levels of membership that are free of charge. Here are four worth checking out: www.absolutearts.com, www.fineartamerica.com, and www.blackartinamerica.com.

78. Send your PR package to everyone you work with, even if you already have the job or commission. They'll learn more about you and there may be more opportunities with them in the future. You can easily send it to them by email.

CHAPTER FORTY-SIX
The Girl Scouts

The same week I received the call from Derry, I also received a call from Milly Hawk Daniell who worked with the Girl Scouts of the United States of America. She asked if I was available to create a painting commemorating the Girl Scouts eighty-fifth anniversary which would be published as a poster. Again, my answer was, "YES!"

I always call that week my "All American Week." Both of these major projects were commissioned in 1996 and unveiled in October 1997. The Girl Scouts unveiled at their National Conference in Dallas, Texas, and the Kwanzaa stamp at the Natural History Museum of Los Angeles for the First Day of Issue Ceremony, October 22nd.

Both events had great press coverage. However, the Kwanzaa stamp unveiling ceremonies started even earlier that year. The first was held in conjunction with the opening of the Museum of African American History in Detroit, Michigan, in April and the second in Winston-Salem, North Carolina, at the National Black Theatre Festival in August.

After the first day of issue on October 22nd, the second ceremony and speaking engagement I attended was at Busch Gardens in Tampa, Florida. I then traveled to speak at an elementary school in Pennsylvania.

My next experience with a home shopping network was with QVC, Pennsylvania. I appeared on air in December for an interview and to boost the sales of the licensed Kwanzaa stamp music boxes and first day of issue cachets.

Art Marketing Tip:

79. Again I'd like to emphasis our need for people skills, including public speaking and for interviews on television and radio, by phone or in person.

CHAPTER FORTY-SEVEN
More Children's Books

In 1997 and 1998, I worked on 2 new children's picture books. One was titled *Greetings Sun*, written by Phillis and David Gershator and published by DK INK. This was the second picture book I created paintings for with Richard Jackson as my editor.

The text read like a simple song and the characters I developed were siblings, a brother and sister. They skipped and hopped and greeted everything from the sun to the moon and the bees and their knees, all in one day.

The other book was based a published song written by Ysaye Barnwell of the a-cappella ensemble Sweet Honey in The Rock titled *No Mirrors in My Nana's House*. The book's title remained the same as the song title.

Both books were released in 1998. My market now included quite a few books, which meant that I was now traveling nationally for book signings, author speaking engagements and conferences.

Art Marketing Tips:

80. Expect your art career to include traveling and choose the mode of travel that suits you. I've always traveled by air, primarily with American Airlines.
81. Enroll in your airline's frequent flyer program. You can redeem your business mileage earned for personal travel and vacations.

CHAPTER FORTY-EIGHT
Can I Touch You

By this time, I was also published by Peter Pauper Press which included two gift books. For *Mother's Love*, I painted the cover art and I wrote and illustrated a book titled *Girlfriends* which was a book of my poetry and prose. *Mother's Love* was released in 1996 and *Girlfriends* in 1997.

During that time, *Can I Touch You: Love Poems & Affirmations*, which I also wrote, was released as an audio book by Music Quest. My friend, Melba Moore, read the affirmations on the recording and I read the poetry to the background sounds of Jazz. We first released the audio book at a women's conference in New York City where Melba and I signed them for the hundreds of women who attended.

In 1998, my cookbook, *Creative Fixings from the Kitchen: Favorite Multicultural Recipes,* was released by Persnickety Press. I had a wonderful book signing reception at the Museum of African American Art in Los Angeles. I even cooked several dishes from my cookbook for the invited guests.

Art Marketing Tips:

82. Develop your own best working schedule. In the creative arts, so much relies on self-discipline.
83. Include some quiet time and exercise to reduce your stress levels and to remain healthy, above all.

CHAPTER FORTY-NINE
Neeny Coming...Neeny Going

Now I'll back up a little and explain how things generally work in the children's picture book publishing industry. A publisher will contract with an author for their manuscript and the publisher, an editor or art director will select an illustrator for the project and make an offer. Author and illustrator never usually meet. If they meet, it usually not until after the book is released. On other occasions, the author may be contracted as both writer and illustrator.

All of my picture books were handled this way except two: *Neeny Coming...Neeny Going* and *No Mirrors in My Nana's House*. With *Neeny Coming...Neeny Going*, I had the opportunity to talk to and meet with the writer, Karen English.

With this particular book, it was very helpful to meet Karen because she shared all her resource information. This enabled me to reflect in my paintings the period the story was set in and reflect what was happening in the history of the Gullah Islands before I even started the dummy book (*drawings*). I love to research not only to learn, but to be accurate in my renderings.

I also purchased a book titled *Daufuskie Island: A Photographic Essay* by Jeanne Moutoussamy-Ashe to visually study the island. I then rented a video copy of the movie *Conrack*, which is the story of the children and the way of life on Daufuskie Island, set around the same period of English's book. I watched the film many times for further accuracy.

Art Marketing Tip:

84. Don't ever underestimate the importance of accuracy. Research all your projects.

CHAPTER FIFTY
No Mirrors in My Nana's House

With ***No Mirrors in My Nana's House***, the fortuitous circumstance was that Ysaye attended the exhibit of my artwork in 1993 in Charlotte, North Carolina, and after seeing the paintings, expressed to the director of the museum her desire to meet me.

This was easily arranged and we met right after I completed the paintings for my first children's picture book, ***Tukama Tootles The Flute***, which I shared with her and Carol Maillard when they visited my home. They spontaneously created and sang a little song to accompany the story.

That afternoon, Ysaye arranged to purchase one of my original paintings, ***"Daughters"***, which was inspired by Julie Dash's beautiful film ***Daughters of the Dust***. We also talked about the possibility of collaborating on a picture book project. I was thrilled.

Within weeks, Ysaye sent me some songs, one of which was "No Mirrors in My Nana's House," and we both began shopping for possible publishers. None of our resources were interested. Our project sat on hold until ironically, Diane D'Andrade from Harcourt Books for Young Readers contacted me about illustrating the book ***Girls Together*** by Sherley Ann Williams.

In our initial conversation, I pitched *No Mirrors* and found out that she had always wanted to work with the group Sweet Honey in the Rock. Not only did we make a deal after some talk and negotiations, Diane allowed me to illustrate *No Mirrors* first so it would be released in the same year that Sweet Honey was celebrating their twenty-fifth anniversary.

This was my only picture book that came with a CD of a song and a reading of the story. It was released in 1998 to rave reviews and it has garnered many honors. Ysaye and I were two of the invited authors to attend a special multicultural children's event at the Kennedy Center in Washington, DC, where we signed our book for the masses.

Art Marketing Tip:

85. Don't give up. Be persistent in pursuing projects you really believe in.

CHAPTER FIFTY-ONE
Harcourt Books for Young Readers

Diane D'Andrade was my favorite female editor. She was a great editor with wonderful suggestions. Like Richard Jackson, she allowed me the creative freedom I really needed and have always cherished.

When I finished the paintings for the book, I didn't feel like just shipping them to her. Fortunately, Harcourt offices were in San Diego, California, less than an hour by plane from Los Angeles. So, I became the courier. I delivered them personally.

Although Diane had trusted her instincts with me, I didn't really complete much of the detail that is usually contained in a dummy book. I immediately saw the relief and delight on her face when she saw the completed paintings.

After she laid all my paintings out on tables in the sequence of the story, she called the other editors and employees in the children's department out of their offices to view them. I have never experienced anything like it. The enthusiasm was magnetic and I returned home on cloud nine.

Right after that delivery, I began work on *Girls Together* as promised. It is a beautiful and simple story about four girls setting out one morning to find amusement for the day. The words in this book read like poetry in dialect. It was released in 1999, right on schedule.

Art Marketing Tips:

86. Whenever possible, work with people you really feel good about working with, especially in the book publishing field.

CHAPTER FIFTY-TWO
Hallelujah! A Christmas Story

Hallelujah! A Christmas Story brought tears to my eyes when I first read it. It is a book of poetry by W. Nikola-Lisa inspired by The Nativity. Nicola-Lisa's book tells the story of the Black Baby Jesus.

The manuscript was submitted to me by Marcia Marshall, a senior editor for Atheneum Books for Young Readers, an imprint of Simon & Schuster. I accepted and signed the contract over a year before I was to begin my paintings. It felt really good to know that I had work scheduled that far in advance.

Speaking of research, I had librarians pulling all kinds of books out for me on the birthplace of Jesus. I needed pictorial information that included photos and geographical descriptions of Bethlehem, the clothing of the people and fine details, including what the candle holders and mangers looked like in that period of history.

The art director I worked with was Ann Bobco and she was an inspiration. Our book, an incredible finished product, was released in 2000. I licensed five of the paintings from the book ***Hallelujah! A Christmas Story*** to Pomegranate for Christmas cards a couple years after the book's release.

Art Marketing Tip:

87. There are endless possibilities for licensing when you keep the copyright to your artwork.

CHAPTER FIFTY-THREE
To Dinner, For Dinner

To Dinner, For Dinner also made its way across my painting table that year. Written by Tolowa M. Mollel, it's a Tanzanian trickster tale about a rabbit that outsmarts a leopard.

I had the opportunity again to work with my incredible editor Mary Cash, who had her eyes opened for another animal tale since the first time we worked together on ***How Mr. Monkey Saw the Whole World***. She was now a senior editor at Holiday House.

Creating paintings for this manuscript was pure JOY for me. I based the rabbit character on my cat Kiku. The rabbit has the same charcoal grey fur coloring and the same white paws, stomach and chest markings as Kiku.

To Dinner, For Dinner is the book I generally choose to read to audiences. I also use it as my teaching tool in my Writing & Illustrating Children's Picture Books workshops.

My only lift-the-flap or novelty book is titled ***It's Kwanzaa Time!*** I had the pleasure of working with my editor Cindy Alvarez for Little Simon, a Simon & Schuster imprint. It was released in 2001.

The lift-the-flap book is a completely different format for children's books. My creativity was challenged by the idea of painting paintings that would be presented in the

book under other paintings and then deciding how and where a flap would be lifted to reveal the words and images underneath.

Art Marketing Tip:

88. Develop reliable and good working relationships with everyone you work with or for. With a good reputation, even more work will be the reward.

CHAPTER FIFTY-FOUR
The Dais

1997 was an outstanding year of winning awards. In addition to the Coretta Scott King Illustrator Honor Award, I received a UNICEF Greeting Card Award, AT&T Entrepreneur of the Year Award, the Treasure of Los Angeles Award and the YWCA Silver Achievement Award. Dais was the new word added to my vocabulary.

The first time I sat on a dais was for the YWCA Silver Achievement Award. As the honorees were introduced at the beginning of the program, we were asked to stand. My fellow honoree, Lisa Leslie, was seated beside me and she was presented first.

When I stood up next, the audience roared with laughter. Lisa Leslie is a 6'5" multi-award-winning WNBA basketball player and she had on 3" pumps. I'm just over 5'2" and I had on flats. What a sight we must have been!

Connie LaFace-Olson, former President of the Los Angeles YWCA Board of Directors, pointed out a gentleman in the audience who wanted to speak with me. It turns out that the gentleman was her husband and that he was the Chief of Exhibits for the Natural History Museum of Los Angeles.

I was completely surprised when he, James Olson, offered me an exhibition at the museum. After we met and made all the arrangements, he also offered me the chance to

curate my own exhibition. He gave me the floor plans for the space in the museum and he let me decide which paintings would be exhibited and where they would hang.

The space was the Rotunda, the museum's most elegant room, lined with marble columns and crowned by a beautiful stained glass dome and a coffered ceiling. It was originally dedicated when the museum opened its doors in 1913.

My exhibition opened in July 1997 and was scheduled to end in December, but it was extended and didn't close until March 1998. My exhibition included thirty original paintings from my *Cultures of the World Series*.

Art Marketing Tip:

89. Recognition awards can lead to so much more. You can't exactly go out searching for these awards or be prepared for them. I certainly wasn't. But your artwork has an impact on more people than you'll ever know.

CHAPTER FIFTY-FIVE
First Day of Issue

What was also so wonderful about these turn of events was that the night before the first day of issue celebration and release of my Kwanzaa Stamp, a gala evening reception was held in the Rotunda. It was a spectacular reception for many who had not seen my exhibition.

The total surprise I received upon arriving for that gala evening was to see the spotlighted 54-foot by 56-foot enlargement of my Kwanzaa stamp draping the whole side of the entrance to the Natural History Museum. Spectacular!

The first day of issue celebration was held the following morning, October 22, 1997. A temporary stage was built just for the occasion in front of the main entrance of The Natural History Museum on Exposition Boulevard.

Along with the specially invited guests, the general public was also welcome. My dear friend Dawnn Lewis served as the mistress of ceremonies. She was the perfect choice for the occasion.

The enlarged stamp still draped the side of the building. However, it was now covered completely by a beautiful red velvet-like cloth. Later in the program, on cue from all on stage, the enlarged stamp was unveiled to thunderous applause.

At the close of the program, I was guided off the stage by three of four bodyguards who escorted me to a table where I signed autographs for an hour or so. Then off to celebrate with family and friends at my favorite Chinese Restaurant, The Palace in Los Feliz.

Art Marketing Tip:

90. I learned that show-woman/-man ship is another important element of successful art marketing.

CHAPTER FIFTY-SIX
Ontario International Airport

In addition to his role as Chief of Exhibits for the Natural History Museum of Los Angeles, James Olson also worked as a freelance curator on other art related projects.

When he received the assignment to commission artists to create artwork for the two new terminals under construction at the Ontario International Airport in Ontario, California, he selected me as one of the artists to submit a design proposal.

When we had our first meeting at the airport, I was under the impression that I would receive a possible commission to design a terrazzo floor. I didn't even know what a terrazzo floor was until James explained and I did some further research. Designing a terrazzo floor would be a challenge that I was more than willing to accept.

However, when I read the assignment sheet, I found that I had been chosen to create a design for a 2-foot-8-inch by 150-foot wall mural for the international baggage claim area of Terminal A.

My immediate thought was ***that's impossible***! I couldn't believe that James thought that I could design something for such a large space and on top of that, meet their deadline.

After the meeting, I spoke with James privately about my concerns. He suggested that I design my artwork for fabrication in ceramic tile. I was only thinking paints and Michelangelo's Sistine Chapel.

To my great good fortune, Ricardo Duffy's assignment was to design and fabricate the baggage claim area of the other twin terminal. Ricardo is an artist who specializes in ceramic tile, so I enlisted his help and he became my first fabricator. In December of 1997, I signed the contract for my first architectural design.

Art Marketing Tip:

91. Always be opened to alternative ways of working on a project.

CHAPTER FIFTY-SEVEN
Glendale Memorial Hospital

Flying high from my Kwanzaa stamp and the incredible project for the airport, I had the opportunity to meet with Michael Pfaff through a friend, Bonnie Homsey. Michael was the president of the Glendale Memorial Health Foundation and this was about the time that I ventured into fundraising on a larger scale.

Michael visited me at home, which doubles as my studio, and came up with a wonderful idea. Glendale Memorial Hospital was renovating part of the fifth floor of the hospital. It would be the new Women's Center. He arranged for us to meet with the president of the hospital, Arnold Schaffer, to discuss commissioning me to create a painting for the lobby of the center.

After my two previous commissions, a painting was certainly doable. Arnold gave me the opportunity to work directly with the architect and the freedom to decide the size of the painting and where it would hang in the center's lobby.

I painted a 3-foot by 6-foot oil on canvas painting depicting a multicultural array of families holding and gazing at their new born babies with love and adoration.

Glendale Memorial Hospital specializes in treating premature babies. I chose the wall that would be directly behind the visitors so that as they were looking through the glass at the babies in their cribs, the babies' view would always include my bright, colorful painting.

I titled the painting *"The Colors of Love"*, and to help raise funds for the foundation, they reproduced the painting as posters and T-shirts which sold in the hospital's gift shop.

Art Marketing Tip:

92. There can be great creative and monetary profit in working with nonprofit organizations and foundations.

CHAPTER FIFTY-EIGHT
The Media

The Kwanzaa stamp gave me incredible national and some international press, the airport gave me tremendous local press and Glendale Memorial Hospital's commission was a feature story in the Los Angeles Times Magazine.

By that time, the Los Angeles Times Newspapers had run a full feature story on me for the Life Style section. My photo was on the cover thanks to the late Gay Iris Parker, who was an incredible publicist, theatre producer and dear long-time friend.

There was also a full-length cover story in the Los Angeles Times Features section. Both stories covered my art career with an emphasis on the Kwanzaa stamp. There were also television interviews for FOX-TV News, ABC-TV News, KTLA News and PAX-TV.

I was interviewed and appeared in *The Story of Kwanzaa,* a syndicated television special produced by Shirley Neal. There were also featured segments on two local Los Angeles television shows, *Life & Times* and *Making It*.

Art Marketing Tips:

93. Press is an incredible art marketing tool. So again, I emphasize the importance of sending out press releases and blogs for all your exhibits, events and on your

accomplishments. You can even list events on many of your local television station's websites and on all your websites.

94. There are quite a few publicists that will work with you on a per-event or per-hour basis.

CHAPTER FIFTY-NINE
Final Jeopardy

Speaking of media, I received a phone call from my friend, Allen Mills, telling me to be sure to tune in to the television show he was working on the following night.

In "television land," some programs are aired on earlier dates in other markets. This was true for Jeopardy. That night after his call, I received phone calls from a couple of my friends back East telling me that my name had been part of the Final Jeopardy question: "The United States Stamp for this December holiday used the work of *Waiting to Exhale* cover artist, Synthia Saint James. Which is?"

I beamed! The Final Jeopardy is the most important question and it gets the most attention and television air time. This was also a special Jeopardy college tournament, and college students were supposed to know the answer. All the contestants got the answer right, Kwanzaa. OUTSTANDING!

That same weekend marked one of the first times I was hired as a keynote speaker. This self-taught artist was to speak at the California Arts Education Association's Convention in Palm Springs, California. I certainly was a bit nervous.

The woman who introduced me shared some biographical information and then announced the fact that my name had been part of the Final Jeopardy question the night before. The audience was impressed and I felt my anxiety lift.

Art Marketing Tip:

95. There are all kinds of artists; don't be intimidated by your degree of education. Some of the most famous and revered artists were self-taught.

CHAPTER SIXTY
Speaking Engagements

I was beginning to feel more comfortable speaking in front of audiences, so I began accepting more speaking engagements and finally started seeking them out.

I began to feel at ease once I realized that some members of the audience are just as nervous as some of the speakers. While working on making my audiences comfortable, I ended up making myself comfortable.

Now more comfortable, I began experiencing creative bolts of energy from speaking to my audiences and hoped that by sharing my journey, I would be encouraging to many in some way.

To date, I've been privileged to speak for several corporations, including Neutrogena and Toyota USA. I've been honored to speak before colleges and universities, including Tennessee Middle State, Barnard, Virginia Tech and Duke.

I've also spoken before centers, museums and groups, including the Schomburg Center for Research in Black Culture, Skirball Cultural Center, National Geographic Society, Japanese American Cultural Center, Museum of African American Art and Sisters at the Well. A more complete list can be found at the end of the book.

Art Marketing Tip:

96. Keep your doors wide open to opportunities. I've found that speaking engagements will help generate art sales, commissions and invitations for more speaking engagements.

CHAPTER SIXTY-ONE
Television and Film

Over the years, my artwork has also been seen on the sets of many television shows, especially sit-coms, including *A Different World, Smart Guy, Martin,The Steve Harvey Show, Sparks, In the House, Moesha, Hanging with Mr. Cooper* and *As For Me & My House.*

My work has also been featured on other cable network programs, including *Just Jordan* on Nickelodeon. Some of the movies in where my art can be seen gracing the set walls are *Law Abiding Citizen, Sunday Morning Stripper* and *Pants in the Family*.

There was also a Jack-In-The-Box television advertisement that featured my 150-foot ceramic tile design in the Ontario (California) International Airport in the background.

I was also fortunate because actors, including Glynn Turman and Dawnn Lewis, requested my artwork as a part of the set design on their television shows. Glynn created the opportunity for the sitcom where he played Colonel Bradford in *A Different World*, and Dawnn for the sitcom where she played Robin Dumars in *Hanging with Mr. Cooper*.

At other times, using my artwork was the idea of the producers or set decorators, including Michele Sefman and Joey DeRosa. This exposure is quite wonderful because thousands, if not millions of people will eventually see your artwork.

This heightens the probability that people will more easily recognize your art when they see it in a gallery or in an exhibition. It becomes familiar to them, especially if they identify themselves with any of the characters on the show.

While a part of the set, viewing your work creates subliminal suggestions or subconscious perceptions that may spark future awareness or recognition of your work – even if viewers can't remember where they've seen your work.

Familiarity with your work can also ignite the bandwagon effect, meaning if "so and so" has your art, they'll have to buy a piece, too. That's true even when "so and so" is a fictional character. Others will simply feel that the art must be valuable just because they saw it on television.

Art Marketing Tips:

97. If you're interested in submitting your artwork to television shows, first research the show by watching an episode or two. See if you feel that your work would fit in with the series theme, characters or decor.
98. Make a list of some possible shows and then send a package to the set designer. Generally, you'll find the name of the set designer in the show's credits or by calling the studio where it's taped.
99. Consider that on some shows, you may not be paid for the use of the art so always submit paintings that you have art reproductions of. Then sell or lend them a reproduction.
100. Learn more about set decorators by visiting the Set Decorators Society of America's website http://www.setdecorators.org.

CHAPTER SIXTY-TWO
Nonprofit Organizations

For many years, walking has been one of my ways for relieving stress and stirring my creative juices. It's also just an exercise that I truly enjoy. There's something about getting out in the open air with nature.

On one of these walks, I began thinking about all the nonprofit organizations that I had donated my art reproductions to for their silent auctions. Specifically, I was thinking of alternative fundraising possibilities that would benefit both the organizations and me more fully.

That was when I began drafting my nonprofit proposal letter. The new concept I developed was to offer to create signature paintings for the organizations that visually conveyed their individual missions or themes for events such as conferences or conventions.

The image could then be used on brochures, invitations, business cards and on their website. However, the most lucrative investment would be in their printing the image as fine art reproductions or posters and selling them to generate ongoing revenue.

I also offer exhibition opportunities where organizations supply the venues, mailing lists and refreshments and I supply my art for sale and then donate thirty to forty percent of all sales, an ideal win-win situation.

The first organization that commissioned me to create an original painting was the 100 Black Men of Orange County. In 1998, Tony Jackson was in charge of the committee and he commissioned me to create an image for their four-year mentorship program for young Black men.

They purchased the original oil painting and we published a limited edition fine art reproduction of the painting which I signed and numbered. The sales of these prints quickly and easily covered all expenses involved and generated a sizable profit that benefited their scholarship fund.

As the artist, I received ten percent of the edition plus a number of the artist proofs. To explain, this means that if 1000 prints were published, I received 100 prints.

This gave me inventory I could then sell to my collectors. This worked very well because there was no need for a monthly or quarterly accounting of sales. I received a percentage of the prints in lieu of a royalty.

Art Marketing Tip:

101. Make a list of organizations you would like to work with or currently work with and make a proposal involving your art or the use of it. Remember, an existing image (painting) could very well be used instead of creating a new one.

CHAPTER SIXTY-THREE
Fundraising Exhibits

My first profitable fundraising exhibit event was for Prototypes. Prototypes is a multi-service agency focusing on helping women and their families deal with severe and complex problems in their lives. Problems which include drug and alcohol abuse, mental illness, HIV/AIDS, homelessness, domestic violence and lack of job/life skills.

Prototypes is also an organization that I had worked with before by donating a percentage of sales at another art exhibition, donating prints for silent auctions and even donating clothing.

I was very familiar with the organization when I met with Andrew Hoffer, who was in charge of the fundraiser that year. Together, we came up with a brilliant plan: For their Sixth Annual Black History Month Gala, they hosted ***An Evening with Synthia SAINT JAMES***.

This was a fine art exhibition and sale that was held at The Beverly Hilton Hotel in Beverly Hills in February 2000. This event was also in celebration my 51st birthday. We put on this event with the financial support of corporate and individual sponsors.

Guests paid $75 each or $750 for a table to attend this exhibition and program where they enjoyed live entertainment, wine and desserts. They were also able to purchase my artwork, knowing that forty percent of whatever sold that evening would be donated to Prototypes.

The event was a huge success. Prototypes made a substantial profit and I gained new collectors and new friends, including Attorney Karen Pointer, and our guests truly enjoyed the evening.

Art Marketing Tip:

102. Two heads are better than one. When you decide to venture into fundraising for nonprofits be sure to send the person in charge of fundraising your proposal. Schedule to meet with them, if possible, at your studio or home where they will be surrounded by your artwork. Together you can create an even stronger proposal to offer to the heads of the organization.

CHAPTER SIXTY-FOUR
Signature Paintings

To date, I have created signature paintings for numerous organizations including, Los Angeles Women's Foundation, Children's Institute International, Maryland's Human Resource Department Kinship Care Program and California State University, Dominguez Hills. A more complete list can be found at the end of the book.

Most of my fine art reproduction inventory is made up of the prints and posters that were published by some of the organizations mentioned above.

I also continue to co-host fundraising exhibitions for nonprofit organizations, including Susan G. Komen for the Cure, Center for the Partially Sighted, Children's Institute International, MOSTE (Motivating Our Students Through Experience), Crystal Stairs and Black AIDS Foundation. I still donate fine art reproductions to numerous nonprofit organizations.

Art Marketing Tip:

103. Some of the organizations that ask for silent auction donations are very open to receiving a percentage of the final bid prices of your artwork. I suggest offering them a donated commission of thirty to fifty percent. This is another way to not only give but to receive.

CHAPTER SIXTY-FIVE
Happy Happy Kwanzaa

In 1998, I received a Women of Vision Award from Black Women Lawyers of Los Angeles and in 1999 I received a NAPPA (National Association of Parenting Publications) Gold Award for co-writing the song *Happy Happy Kwanzaa* with songwriter Bunny Hull.

Yes, that year I joined BMI (Broadcast Music Inc.), a nonprofit organization that looks out for the licensing fees and royalties due songwriters. My music publishing company is titled Synthia SAINT JAMES Music.

The song *Happy Happy Kwanzaa* was packaged with my first children's activity book published by Bunny Hull that included a coloring book and crayons. This first activity book would later parachute into four activity books. Our complete list of activity books include *Happy Happy Kwanzaa, Alphabet Affirmations, Peace In Our Land* and *Dream A World*. Bunny and I have received awards for all four of them.

Art Marketing Tip:

104. There are and always will be numerous new markets and opportunities for your art such as activity books. Someone is always looking for an artist/illustrator to bring their writings to life. Many opportunities can be found by doing research on the internet. Always be open and willing to expand.

CHAPTER SIXTY-SIX
Recognition Awards

I received the Literary & Visual Arts Award on the 115th Anniversary of the Second Baptist Church and a Talent Award from the Los Angeles Chapter of the Links in 2000. In 2001, I received The Arts Council Award from the California African American Museum and the Oppenheim Gold Award for illustrating *To Dinner, For Dinner* written by Tololwa M. Mollel.

I received the Ebony Excellence: Women of Vision award from the Mu Beta Omega Chapter of the AKAs and the Sisters Award from the National Alumni Association Spelman College in 2002. In addition, I received The Woman of the Year award in education from Los Angeles County Commission for Women and The History Makers Award in 2004.

Art Marketing Tips:

105. Whenever possible try to include a small exhibition and sale of your artwork at your award events. With nonprofit organizations, I always donate a percentage of sales to their scholarship or community programs.
106. If an organization requests use of your artwork on their invitations or brochures for an event, ask if it would be possible to have some of your art at the actual event available for sale and offer them a small commission.
107. Remember that awards are important because they recognize your achievements and because they introduce your artwork to others that may not know you or may not know how to contact you.

108. Always be gracious, humble and thankful. No one enjoys the company of someone who believes that the world revolves around them.

CHAPTER SIXTY-SEVEN
Enduring Wisdom

I was offered and accepted the opportunity to create paintings for a Native American children's book for Holiday House in 2002. My editor at Holiday House, Mary Cash, knew I had written a few Native American books and that I longed to have one published. So when *Enduring Wisdom: Sayings from Native Americans* was compiled and edited by Virginia Driving Hawk Sneve, she immediately thought of me.

What is unique about *Enduring Wisdom* is that it may be in a children's picture book format of 32 pages, but it's really a book for people of all ages. Profound and simple truths are addressed about Native Americans by Native Americans from various American Indian tribes dating back to the 1600s.

Released in 2003, this was the last picture book I illustrated because I decided to take a hiatus from picture books. Since my airport mural, I had become very intrigued with architectural design and I wanted to explore the possibilities.

In the spring of 2001, I responded to a call for artists I received in the mail and to my surprise, I was one of the five chosen to design elevator doors for the Capitol Area East End Complex in Sacramento, California.

This complex is adjacent to the California State Capitol Building and is composed of office buildings for various government agencies. We were all assigned different

buildings and our designs grace the elevator doors in the lobbies of each building. My six 9-foot by 4-foot elevator doors are in the lobby of 1501 Capitol Avenue.

Art Marketing Tip:

109. If you have an interest in public art, contact your local and national public art resources such as the cultural affairs department. You will usually be able to add your name to their list of artists or submit an application to be added to their mailing list for public art notices.

CHAPTER SIXTY-EIGHT
Elevator Doors

This was a wonderful and challenging experience because first I had to learn how to design for elevator doors. It also was an opportunity to work with Tamara Thomas and her company, Fine Art Services. I was sent photographic examples of the metal etching process used and the requirements for the preliminary design stage.

My preliminary designs were the first elements needed. When they were approved, I drew them to scale. With the aid of modern technology, my job was simple and I was so excited about this project that I finished well before the due date, as I generally do. I can't stand pressure.

Samples were later sent for my approval and the final installation of the doors was completed in 2003.
There is a book titled ***Capitol Area East End Complex: Public Art Interactive Catalog*** which contains an interactive DVD with interviews of all the artists that designed and worked on this massive project. Along with photographs, there is video footage on the entire complex.

Art Marketing Tip:

110. Don't be afraid to challenge your creative ability. You'll create artwork that you may never have imagined.

CHAPTER SIXTY-NINE
Stained Glass

I've always been fascinated with stained glass design. I was thrilled when Jan Stein and I became acquainted. Jan was the Program Coordinator for Hillsborough County's Public Art Program at the time.

She initially knew of my work from the first corporate commission I completed for the House of Seagram, ***"With Honors"***. A lithograph of the painting hangs in one of the offices in Tampa, Florida, so she wanted to establish contact with me.

When I expressed my interest in designing stained glass, she raised her antennas high and after some time, a project finally surfaced that she felt would be perfect for me. The West Tampa Library is a Carnegie Historic Library and it was being refurbished.

I was commissioned to design stained glass for three windows for the reading room. Each windows measures 49-inches by 20-inches. For this project, I was asked to paint the designs on canvas for the three windows, to actual scale size. These paintings now hang inside the library.

Based on the paintings and a color chart I provided, my designs were fabricated into glass by a local Tampa stained glass artist. Reggie sent me a box of sample glass that he thought best matched my colors and I chose the glass to be used from the many textured designs available in each color.

It was an amazing experience that I would like to duplicate, again and again. The installation of my stained-glass design was completed in December 2004.

Art Marketing Tip:
111. Isn't it interesting how one project led to another nearly fourteen years later? I truly believe that whatever we put out there will come back to us in some shape or fashion.

CHAPTER SEVENTY
The Wonder of Reading

In 2004 Gibson, Dunn & Crutcher LLP, a large international law firm, partnered with the Wonder of Reading Program. The Wonder of Reading Program is a nonprofit organization that connects Los Angeles County elementary schools whose libraries are outdated or rundown with community partners willing to embrace renovating and restocking the libraries with new books and willing to volunteer to read to the students.

Gibson, Dunn & Crutcher went a huge step further when they had one of the lawyer's research and find an artist to commission for this project. The lawyer googled the word diversity, the project's theme, and as fate would have it the title of my150-foot ceramic tile mural at Ontario International Airport is *"Diversity"*. He then googled my name and found my website. When he called we had a wonderful conversation about the project and my possible inclusion.

A meeting was set up with Bill Wegner and the special planning committee for the project in the firm's downtown Los Angeles offices the following week. I'm certain they immediately picked up my enthusiasm for project, so they filled me in on what was to be a huge surprise at the firm's retreat, held every three years for their 800 attorneys at the La Quinta Spa & Resort in Palm Desert, California.

The surprise guest keynote speaker was Dr. Maya Angelou and only the committee knew. They commissioned me to design a 4-foot by 7-foot ceramic tile mural based on Maya Angelou's inaugural poem, "On the Pulse of Morning," written for President Clinton's first term of office.

I had the privilege of working directly with Bill Wegner and the entire planning committee for the retreat. They were all so incredibly enthusiastic and creatively delightful.

The title of the mural is *"A Rock, A River, A Tree"*, taken directly from Dr. Angelou's poem. After preliminary drawings, I drew my design to scale using the same technique I used for the 150-foot airport mural. Again, I provided a color chart and designated the placement of the colors to Ricardo Duffy, my fabricator and the same artist that worked with me on the airport project.

We had two actual unveilings: one at Gibson, Dunn & Crutcher's Attorney Retreat in May, 2004 just before Dr. Maya Angelou gave her mesmerizing keynote speech and again after the final installation of the mural at Cowan Elementary School in Westchester, California, in February 2005.

Talking about creativity! After the surprise introduction of the keynote speaker and her arrival on stage, the technicians filled the entire backdrop of the stage with my painting, *"A Rock, A River, A Tree"*.

Yes, I had decided to paint the design too. I presented Dr. Angelou with a beautifully framed 1/20 Artist Proof Giclee on Canvas of *"A Rock, A River, A Tree"* right after she completed her keynote for which she received a thunderous standing ovation.

Art Marketing Tip:

112. Again, I must emphasize the importance of creating a website. One of the lawyers at Gibson, Dunn & Crutcher went online looking for artists whose artwork included diversity. My 150-foot airport mural is titled *"Diversity"*, therefore, I was one of the first considered for the job after they visited my website.

CHAPTER SEVENTY-ONE
Written Contributions

I have also contributed my writings to books by other authors, including an essay for Tavis Smiley's ***How to Make Black America Better***, my story included in ***The Milestone Project*** by Dr. Richard & Michele Steckel and the foreword to ***Who's Who Among African Americans***.

Synthia SAINT JAMES: A Book of Postcards, released by Pomegranate in 2004, contains 30 large postcards of my paintings. For me, the postcard book is the prelude to the coffee table book that I've been dreaming of.

Art Marketing Tips:

113. Go for whatever your creative heart desires.
114. Create IT and make IT happen!!!

CHAPTER SEVENTY-TWO
Washington Mutual Bank

Washington Mutual Bank's advertising company called me and requested the use of one of my paintings *"Legacy"* for Black History Month 2004 and they were under a tight deadline - which often happens in the art and advertising business.

"Legacy" was a painting commissioned for another project at least ten years prior and I owned the copyright to the image. I knew I had a reproduction transparency made of the painting and hoped to find it in my safe deposit box. My safe deposit box contains hundreds of my reproduction transparencies and other important papers. I was so relieved when I found *"Legacy"*.

They devised a brilliant ad campaign in which the general public could receive, free of charge, an 18-inch by 24-inch poster of *"Legacy"* just by visiting one of the bank's branches. The poster was also a 2004 calendar which included my bio and information on WAMU.

Along with licensing the use of *"Legacy"*, I was paid to make appearances in three major cities - Harlem, New York, Atlanta, Georgia and Los Angeles, California - to sign the posters for the general public.

The events were all well-advertised by each city's local radio stations and each station also broadcasted live interviews with me. The turnout was fantastic; we had huge lines of people in every city.

Art Marketing Tips:

115. Again, make sure to get high-resolution, reproduction quality scans done of your artwork. I have hundreds of reproduction transparencies stored. But with the new technologies, I now have my paintings scanned professionally onto a CD.

116. Find a safe place to store your transparencies and disks and make sure that you can retrieve them on short notice. I had only one day to find my transparency for *"Legacy"* and I had to ship it to the ad agency FEDEX overnight to meet their deadline.

117. When negotiating a licensing contract that includes appearances and travel, be sure to factor in an additional fee.

CHAPTER SEVENTY-THREE
Nafissah Art Collectibles

My most outstanding exhibition to date was with Nafissah Art Collectibles in New York City in 2005. The owner, Lailah Greene, went all out from her exquisite framing of my artwork to the ambience of the special event space that she rented in the Flatotel for the exhibition.

The Flatotel is a luxurious boutique hotel on 52nd Street in Manhattan frequented by the elite in the entertainment business. Lailah also booked me into a spacious 2 bedroom suite in the hotel. For the two art receptions held, all I had to do was take the elevator to the hotel lobby. We had a wonderful turnout, especially at the opening reception, and our art sales were outstanding.

Also in 2005, I created a painting titled ***"Break The Silence"*** for the Center for Disease Control and the National HIV/AIDS Partnership. I was one of three minority women commissioned. We represented three ethnic groups - African American, Native American and Latin American.

Our mission was to each create a painting representing our ethnic group with the focus on HIV and Aids awareness and testing. Our paintings were reproduced as posters and placed on awards.

On World AID's Day, December 1, 2005, our paintings were unveiled at a special ceremony at the United Nations Building in New York City. Guest speakers included

Nancy Wilson. Two of the award recipients were Sheryl Lee Ralph and Martha Redbone, who were honored for their work in the fight against the deadly disease.

My original painting was later purchased by one of my collectors, Dr. Walter Allen. He gifted it to Spelman University, where it hangs today in the President's Office.

Art Marketing Tip:

118. As an artist, give back by aligning yourself with causes dear to you or to nonprofit organizations.

CHAPTER SEVENTY-FOUR
"Let Somebody Know"

A good friend and collector, Gloria Thomas, called me with a wonderful commission idea. Her church, The Metropolitan AME Church in Harlem, NY, needed some restoration funds and she wanted me to create a painting that we could reproduce as limited edition prints. So, I did.

"Let Somebody Know", is titled after a very inspirational song written by my friend Brenda Russell. We unveiled the original and a framed limited edition print at the Schomburg Center for Research in Black Culture, which is also in Harlem and right down the street from her church.

Most of the church's congregation and some of my very special guests, including my "Big Sis" Barbara Montgomery and my friend Carl Gordon, were in attendance.

Gloria's mission was accomplished. She completely covered her expense of commissioning me and she was able to make a sizable contribution to her church from the sales of the limited edition prints.

In my agreements with nonprofit ventures, I receive a number of the prints for my inventory which I'm able to sell to my collectors or donate to silent auctions.

Art Marketing Tip:

119. Look into the possibility of creating something for

your church or place of worship. Also, let your friends and coworkers know you're available for fundraisers.

CHAPTER SEVENTY-FIVE
Tom Joyner's Fantastic Voyage

I was never much for cruise ships. When I take a vacation I like to get to the destination as soon as possible, by airplane. I then soak up the culture of the country as much as I can in what is usually at least a week.

One friend who loves to cruise told me to think of the cruise ship as the destination. So, in May 2006, I was one of the featured visual artists aboard Tom Joyner's Fantastic Voyage. I really had no idea of what to expect except that Tom did tell me that his cruise was most definitely a 24/7 party cruise.

One of the main objectives of his annual cruise is the raise money for Historically Black Colleges and Universities. So as visual artists, we were there to sell our artwork and to then donate a percentage of our sales to the Tom Joyner Foundation for HBCUs.

After calling two of my friends and former personal assistants, Tonda Case and Nike Irvin, I decided to GO FOR IT. They both were able to come and were excited about it. Because Tom provided me with my stateroom and their stateroom free of charge, I felt like I was also giving them a vacation as a "Thank You" for all they'd done for me.

On the cruise that began in Puerto Rico, my primary expenses included shipping my artwork to Puerto

Rico, two airfares and other incidentals. The three of us met in Puerto Rico and we were off to the ports of Barbados, St. Lucia and Saint Martin. I had visited all three, so I was also able to share a couple of my favorite beaches and island dishes with Tonda and Nike.

I'm an early riser, so each morning found me on the top deck power walking around the track and after breakfast, checking in with the girls, visiting ports or sitting by my exhibit of art (for which we all took turns).

Unfortunately, I didn't do well financially because of the shipping and traveling expenses to and from Puerto Rico. However, I did make some good connections and we all enjoyed a memorable adventure that included great fun!

Art Marketing Tips:

120. It's impossible to foresee the outcome of all our investments, but we never know unless we try. Some of the more seasoned artists did quite well financially on the cruise.
121. Make the best of all situations. I made several new friends who later became collectors and got reacquainted with an old friend.

CHAPTER SEVENTY-SIX
Coincidence or Kismet

Soon after returning home from the cruise, I was contacted by an advertising agency interested in using my artwork in a promotional campaign for the Royal Caribbean Cruise Ship Line, the same line that Tom Joyner uses for his cruises.

Her name was Nabeeha and we later became great friends. Ironically, she was on my first cruise for just a few days (the cruise was a week-long) but we never met. Royal Caribbean's advertising agency developed a promotional campaign to raise funds for visual arts education primarily for African American children.

Live art auctions were held on Royal Caribbean Cruise Ships docked in San Pedro, California, and Baltimore, Maryland. Several of my artworks were included in both auctions, where a percentage of the final bid was donated to the educational fund.

My artwork was the featured artwork on all advertisements, invitations and on Royal Caribbean's official website, so my art was seen by thousands daily. I was also asked to speak about my art at the auction in San Pedro. Outcome: All my artwork sold.

Art Marketing Tip:

122. My investment in Tom Joyner's cruise paid off after all. My art was seen by Nabeeha on board which led to major exposure and great art sales.

CHAPTER SEVENTY-SEVEN
Ambi - Johnson & Johnson

Working with Nabeeha on her Royal Caribbean account led to working with her on the launch of the Ambi Skin Care Line with Johnson & Johnson. The Ambi Skin Care Line was developed for women of color and I painted several paintings featuring multicultural women.

One painting was for the Los Angeles Women's Foundation titled *"Of Many Colors"*. Nabeeha chose this one to introduce at her initial meeting with Johnson & Johnson and they felt that it was perfect for their targeted market.

I made appearances at two events that launched the Ambi Skin Care Line. The first was in San Francisco at the Museum of the African Diaspora where they hosted an evening reception for the dermatologists who were attending a national conference in the city. They gave my postcard books out as gifts, which I signed and personalized for the guests.

The second was at a plush boutique hotel in New York City. This event was primarily for the media and special guests. The afternoon included lunch and a presentation about the product line. Each guest received a framed *"Of Many Colors"* print, which I handed them as they left.

Art Marketing Tips:

123. *"Of Many Colors"* was existing art. Again, I highlight the importance of owning your copyright and of having a suitable transparency or scanned CD for reproductions

124. You are considered a part of your art, so always be prepared to "meet and greet."

125. Submit your artwork to Advertising Agencies for review.

CHAPTER SEVENTY-EIGHT
Creating Awards

The first time I was asked to create an award was in 1993. My friend Ron Glass needed one for the Al Wooten Jr. Heritage Center in Los Angeles, California. Ron served on the board.

At first, I was stumped. Then I remembered seeing awards that were made out of some kind of clear material, similar to hard plastic, in which some kind of material was then floated inside. My thought was to first create a painting and have a reproduction transparency made. From the transparency, I'd have a small art print made to float within the trophy-like award. It worked beautifully!

The next time I was approached was several years later by my dear sister friend Barbara Perkins for the We See You Awards, which was first presented in October 2006 at the Skirball Cultural Center in Los Angeles.

Again, I created a signature painting. I then had it scanned and reproduced as giclees on canvas. One of the unique things about this is that it was the first giclee on canvas of my work that will never be sold. It will only be presented as a framed award to the honorees each year in October at the award ceremonies.

Some of the past recipients include New York Times best-selling author and television personality Iyanla Vanzant, Member of the U.S. House of Representatives Diane Watson from California's 33rd Congressional District

and choreographer extraordinaire Eartha Robinson.

In 2010, I was commissioned to create two new awards. The first was for the Mosaic Woman Award for Sheila Robinson's *Diversity Woman Magazine*. I made the same arrangement with Sheila that I made with Barbara; only honorees will receive this giclee on canvas. Some of the past recipients include Dr. Maya Angelou, Tena Clark and Dr. Johnnetta Cole.

The second award was a very HUGE honor for me. I felt like I received an award!!! Dr. Cynthia Jacobs Carter of Africare commissioned me to create an award for His Excellency Nelson Mandela, a Lifetime Achievement Award. His daughter and his grandson accepted the award for him in Washington, DC.

I created the painting and had it reproduced as a limited edition giclee on canvas, from which Nelson Mandela received the 1/30 Artist Proof custom framed with an engraved plaque. *"Madiba Mandela"*, the limited edition giclees on canvas, are available for purchase on my website.

Art Marketing Tip:

126. Keep your mind wide open to new opportunities. I never could have imagined that I would create awards.

CHAPTER SEVENTY-NINE
Ambassador Synthia SAINT JAMES

In 2008, I was contacted by Andrea Anderson who was the Director of Integrated Marketing for Susan G. Komen for the Cure, the world's largest grassroots network of breast cancer survivors and activists.

I was elated to find out that they were interested in commissioning me to create a signature painting for their new Circle of Promise campaign, which was established to create more breast cancer awareness and testing among African American Women.

They also invited me to join their prestigious list of ambassadors which included Xernona Clayton, Rene Sylar, Lalah Hathaway and Gabrielle Union.

Of course, my answer was, "YES!!!" After a couple of phone conferences and my research, I created the painting *"Circle of Promise"* which was unveiled at an exclusive luncheon hosted by the National Chapter of the Links, Incorporated at the Newseum in Washington, DC. If you search my name on YouTube, you'll find the unveiling ceremony video.

The signed and numbered limited edition prints were released at the luncheon and later sold on the Circle of Promise's website to help raise funds for the ongoing fight against breast cancer.

Art Marketing Tip:

127. Take full advantage of websites such as www.YouTube.com. Upload and broadcast videos of your events, interviews and promos.

CHAPTER EIGHTY
Woman of the Year

Then California Senator, Mark Ridley Thomas, surprised me with the amazing honor of Woman of The Year 2008 for the 26th Senatorial District.

The morning ceremony was held in the California State Senate Chambers in the Capitol Building in Sacramento, California, where a total of 40 women were honored. We were honored for our individual accomplishments and for our contributions to the State of California.

We were introduced individually before we walked down the aisle with the senator who had chosen us to receive the awards. Family, friends and guests were seated in the balcony overlooking the California State Senate Chambers.

My sister, Trena James-Cook, overcame her fear of flying to attend. My dear friend Tonda Case drove up from Oakland with her two girls so that they could witness their Godmother receiving the award and my great friend and photographer Leroy Hamilton flew up from Los Angeles to capture all with his camera. In addition, my friend and collector Yvonne White lent me her parents for a day of local support.

After the ceremony, Senator Mark Ridley Thomas treated me, my guests and his staff to a superb dining experience at one of Sacramento's finest restaurants. We also had the opportunity to visit the elevator doors that I had designed for 1501 Capitol Avenue office building's lobby in the East End Complex where Leroy captured some fantastic photos.

Art Marketing Tip:

128. Look for ways that you can help your local community or communities through your artwork. Example: Teaching an art class for children or adults.

CHAPTER EIGHTY-ONE
Tuscany, Italy

In the fall of 2008, I was invited by my "Big Sis," Barbara Montgomery, to join her for a week's vacation at a villa in Tuscany.

Several years prior, I only touched ground in Italy while traveling through Mont Blanc from France just to have my passport stamped *Italy*. So I was certainly interested in the possibility of visiting this beautiful countryside.

I checked my frequent flyer mileage with American Airlines and found that I had enough redeemable miles to fly first class roundtrip to Rome, so I booked my passage immediately.

After meeting Barbara in Rome, we traveled by train to Tuscany. The beautifully restored villa where we stayed was located on the Palazza Wine Vineyard Estate in Montalcino, Italy.

While in Montalcino, we traveled by car to some of the surrounding areas in Tuscany where I was wowed by the expansive fields of sunflowers, incredible Cypress trees on hills of green and other panoramic landscapes which I painted when I returned home.

Dr. Natalie Sanders, a good friend and avid collector, purchased the first painting titled *"A Taste of Tuscany"*. The other three paintings in the quartette are titled *"Tuscan Sunflowers"*, *"Cypress Trees"* and *"Tuscan Autumn"*.

Art Marketing Tip:

129. You'll find inspiration everywhere if you're open to it.

CHAPTER EIGHTY-TWO
Turning Sixty

I promised myself that I would wake up in a country I had never visited on my sixtieth birthday. When I started researching possibilities, I recalled the reception I attended in Hollywood for the Turks & Caicos International Film Festival hosted by Jasmine Guy.

The presentation that afternoon included a film on the Turks & Caicos Islands and I especially remembered the turquoise water and white sand beaches. My decision was made and with the help of my American Airlines redeemable miles balance. I was again able to treat myself to this mini vacation and first-class tickets.

I also made my reservations for my stay at The Alexandra Hotel in Grace Bay, Providenciales which was recommended to me by my friend, Tommy Dortch.

I arrived the evening before my birthday and I met the sunrise walking the white sand beach on the day of my birth. For my birthday, I had also booked a private excursion to the outer islands of Middle Caicos and North Caicos.

My favorite island is Moorea in Tahiti where my favorite waters are the beautiful lagoons. You can see right through the water to the bottom of the sea and everything in between. But in the Caicos, the water was unbelievably turquoise and in some places, appeared as dense as oil colors, especially when I was on the ferry boat.

My last day was spent walking the beach at dawn and later that day I booked a taxi to take me around Providenciales so I could see some of the places that the tourists don't frequent, something I try to do every time I travel. This helps me to better soak up the cultures and inspirations for my paintings.

Art Marketing Tip:

130. When you travel, safely experience as much of the culture as possible. It can be so inspiring.

CHAPTER EIGHTY-THREE
Barnes & Noble

On September 25, 2008, I was contacted by Jennifer Kay, Product Development Manager for Barnes & Noble, regarding a special store promotion that she wanted to submit my art for. She informed me that they were on a very tight schedule so I sent her my art package via FEDEX overnight.

Exactly one week later, I received their letter of interest in licensing *"Brilliance"* for their Black History Month promotion in February 2009 and their standard licensing contract for my approval.

Time was of the essence. I immediately needed to contact my color lab, Crush Creative, and have them create the reproduction CDs and the Color Match Prints needed to reproduce my artwork on tote bags and journals.

The CDs were then shipped FEDEX to Jennifer Kay at the Barnes and Noble New York City offices and received on October 10. By mid-October, our licensing contracts and other required legal documents were signed, setting me up as a Barnes & Noble vendor and on November 5, I was able to submit my first royalty invoice.

Unlike any other licensing agreement that I've had, Barnes & Noble requested invoices from their licensors right after they placed their orders for the merchandise to be produced by their manufacturers. Turnaround time to receive your royalty payments were approximately thirty days after the invoice was received.

I was traveling to New York for an exhibition in early December and I was graciously invited to Barnes & Noble's office to meet the key people in gift merchandising.

Jennifer gave me a tour of the offices and I had the chance to meet Jeanne Allen, the Director of Product Development and the Vice President of Gift Merchandising, Bill Miller, among others. I also had the chance to see my final products, the tote bag and the journal. Both were beautiful!

In the meeting with Bill Miller, Jennifer and Jeanne, I was asked if I would be interested in creating a new painting for tote bags. Needless to say, I was completely excited by the possibility. The bags were released in February 2010 for Black History Month.

"Butterflies Dream" was reproduced not only on tote bags, but on journals and sixteen-ounce tumblers. As with *"Brilliance"*, the products sold in all Barnes & Noble's 800 stores and on their website. All products sold out the month they were released.

Jennifer and Jeanne took me out to lunch after our meetings and we celebrated our alliance and since the first products would be available in February 2009, we had an advance celebration of my 60th birthday.

Barnes and Noble was definitely a gift for me. They also used my artwork on the in-store marketing materials that first year and on their website, for which I received an additional fee.

For further promotion, I made two appearances, one at their Americana store in Glendale, California and the other at their Grove store in Los Angeles, California where I read a couple of my children's books and signed autographs.

Art Marketing Tips:

131. Immediate follow up is essential. If I wasn't prepared to follow up, this wonderful licensing partnership would have never happened. Establish a FEDEX or UPS account in your name or business name. You will be able to put together whatever is needed and call in for a pick up for overnight delivery and you'll be able to pay later.
132. In some cases you'll need some upfront money or you can use a credit card to have your color lab transfer your art into whatever form needed by the person or company you're working with. Just be sure to invoice them for reimbursement as soon as possible. Some companies may take thirty days to generate a check back to you.

CHAPTER EIGHTY-FOUR
My Second Fantastic Voyage

Tom Joyner's 10th anniversary Fantastic Voyage Cruise sailed out of Long Beach, California, a first. I was one of the two California artists invited to exhibit and sell art on board. The other was my best artist friend and collaborator, Charles Bibbs.

I live no more than an hour from Long Beach in Los Angeles and Charles lives in Riverside - about the same distance from Long Beach. It was perfect for the both of us.

With no round-trip airfares and no art shipment fees to be paid, Charles simply drove our artwork to the storage area for the ship, so our overhead was sharply reduced. We also arranged to have our art exhibits set up side by side at one end of the Promenade Deck and directly in front of the room where all the live art auctions took place. An ideal spot!

My friend and assistant, Tonda, joined me again. Charles' wife, Elaine, and his assistant, Maxine, were with him. We were fully staffed and able to arrange ample breaks for all. I also had a better sense of what artwork I should bring after my first Fantastic Voyage, which included a portfolio of my artwork that could be ordered.

Everything worked out well. Both Charles and I made a profit and we were able to contribute a sizable amount to Tom Joyner's Historically Black Colleges and Universities Scholarship Fund.

My first added bonus from this cruise was visiting Butterfly's Garden in Victoria, British Columbia where I photographed several beautiful butterflies which I later painted.

The second bonus was meeting Dr. Dianne Boardley Suber, President of Saint Augustine's College.

Art Marketing Tips:

133. Learn from experiences and plan accordingly.
134. Set some goals for yourself. One of my goals was to connect with Historically Black Colleges and Universities and to develop relationships with them.

CHAPTER EIGHTY-FIVE
Crowns

The highlight of 2009 was creating a painting based on Regina Taylor's musical play *"Crowns"*. I was formally introduced to Regina by Ambassador Attallah Shabazz, who thought my artwork would be perfect for marketing and merchandising this incredible play.

It was an honor and delight to work with actor and playwright Regina Taylor. We met when she visited my home studio with her assistant to see my original paintings and to discuss direction and possibilities. We clicked creatively.

Creating artwork for a play is especially rewarding to me because of my early background as an actor and because I love the theatre and many of the magnificent actors who bring it to life. I simply titled the completed original 40x30" acrylic on canvas painting *"Crowns"* and I love that Regina Taylor owns the original painting.

The first theatre to use my commissioned artwork for advertising the play was the Pasadena Playhouse in Pasadena, California. Gay Iris Parker suggested that I have an art exhibition at the theatre during the run of the play as well, and I did. On the opening night for *"Crowns"*, the theatre also hosted a very successful art reception for me.

There were limited edition prints, posters and T-shirts created for merchandising and I received ten percent of

both the limited edition prints and posters and a dozen T-shirts for my personal use.

Art Marketing Tip:

135. When creating artwork that will be used on merchandise for a client, always remember to include a provision in the contract to receive a percentage of the prints or a number of the products. Or if you're creating for a for profit organization, include a provision that you'll receive a royalty on sales.

CHAPTER EIGHTY-SIX
Rainbow Dreams Academy

I met Diane Pollard in Los Angeles, California at Xernona Clayton's One-Woman Show, which was a benefit for Susan G. Komen for the Cure.

We exchanged cards and she later contacted me to ask if I would be the featured, solo artist for a fundraiser she was planning for her charter school, Rainbow Dreams Academy in Las Vegas, Nevada. What was my answer? *YES*! Raising funds for young and gifted African American children? MOST CERTAINLY!

She was and is a wonderful host and friend. What was so incredible was all that came out of our two-day exhibition. I had already established a bank business account many years ago, so I had merchant status and could accept credit and debit cards as payment. But I hadn't invested in a wireless terminal.

For this exhibition I decided that it was most definitely time to do so. I started calling that wireless terminal the only slot machine that I would ever need. I don't gamble, other than taking the many chances I have taken for my art career over the years.

In just two days, I charged over $16,000 in art sales, of which about $7,000 went to Rainbow Dreams Academy.

Art Marketing Tip:

136. In this day of "plastic," you most certainly need to be able to charge to credit and debit cards especially for the impulse buyers.

CHAPTER EIGHTY-SEVEN
The Trumpet Award

There was only one other time in my life when I was informed that I had to keep FANTASTIC news to myself until it was officially announced.

The first time was when I was commissioned to design the first Kwanzaa stamp for the United States Postal Service in October 1996, a year before it was released in October 1997.

The next time was in April 2009 when I received a letter that informed me that I would receive The Trumpet Award on January 30, 2010. I was literally on pins and needles until I received the official invitation to attend The Trumpet Awards in late November 2009.

I was attending a Kappa Alpha Psi Fraternity event when a wonderful woman came up to me and congratulated me on my upcoming Trumpet Award. I was so stunned and surprised that I had to ask her how she knew. She said that she had just received her invitation to the Trumpet Awards.

I received my invitation in the mail two days later. If there is a cloud twice as high as CLOUD NINE, I was on it. I saw my name spelled exactly how I spell it, Synthia SAINT JAMES, and the category the Arts. I was the first painter to be so honored.

My dear long-time friend, Geoffrey Macon, not only

designed the outfit that I wore to receive my Trumpet Award, but he escorted me to many of the festivities in Atlanta, Georgia. We attended the International Civil Rights Walk of Fame Inductees Breakfast, the Induction Ceremony at the Ebenezer Baptist Church and the Sponsors and Honorees Dinner.

On the day of the Trumpet Awards Ceremony, we walked down the Red Carpet together to our front row seats at the Cobb Energy Performing Arts Centre where the ceremony was taped for international viewing before close to 5,000 people.

The evening was capped off with a Post VIP Reception, appropriately named the "Soulful Ending." As far as I'm concerned I've received my highest honor, my Oscar, from Xernona Clayton's Trumpet Award Foundation in the Civil Rights category and I cherish it as just that and more!!!

Originally presented by Turner Broadcasting in 1993 and now presented by the Trumpet Awards Foundation, Inc., the Trumpet Awards were created "...to herald the accomplishments of Black Americans who have succeeded against immense odds. Special recognition is given to the few, who symbolize the many, who have overcome the ills of racism and poverty and achieved special greatness..."

Art Marketing Tips:

137. Always have a supply of your professional business cards with you. You never know who you may meet.

138. Make sure to get copies of all videos and some photos from your events. They are great marketing tools that can be used on your website and upload it to YouTube. I have a couple of links to my YouTube videos and a link to my website in the signature area of my email.

CHAPTER EIGHTY-EIGHT
NAWBO-LA Hall of Fame Inductee

The National Association of Women Business Owners –
Los Angeles (NAWBO-LA) is one of the organization's
leading and innovative chapters since its beginnings in
1979. The mission of NAWBO-LA is to, as stated on
their site, "...propel women entrepreneurs into economic,
social and political spheres of power by: *strengthening* the
wealth creating capacity of our members and promoting
economic development within the entrepreneurial
community; *creating* innovative and effective changes in
the business culture; *building* strategic alliances, coalitions
and affiliations; and *transforming* public policy and
influencing opinion makers."

On March 14, I received the NAWBO-LA's Hall of Fame
Inductee Award, my second prestigious award in 2010.
Again, as with the Trumpet Award, I was the first painter
to be so honored. I had followed in the footsteps of Bettye
Dixon, President and CEO of Concourse Concessions,
Inc., a woman I truly admire. She received the award in
2009.

This award was championed by Daphne Anneet and Jane
Pak and I'm deeply grateful.

Art Marketing Tip:

139. At business networking events, politely introduce
yourself to the other people in attendance, it's expected.
That's what you're there for.

CHAPTER EIGHTY-NINE
Saint Augustine's College

Saint Augustine's College was founded in 1867 in Raleigh by prominent Episcopal clergy for the education of freed slaves. Located in North Carolina's capital, Saint Augustine's College boasts a beautiful 105acre campus. The campus' 37 historic and contemporary buildings are just minutes from downtown Raleigh's commercial, educational, governmental and entertainment centers. Three of its buildings - the Chapel, St. Agnes Hall and Taylor Hall - are registered historic landmarks.

I was invited to speak at Saint Augustine's College by the President, Dr. Dianne Boardley Suber, soon after meeting her on Tom Joyner's Fantastic Voyage in May 2009.

My first visit to Saint Augustine's College was in September 2009. I worked with art students in the morning and in the afternoon Dr. Suber introduced me at the luncheon they held for me. Faculty, staff and some students attended this luncheon.

During my Q&A at the luncheon I was asked what I'd like my legacy to be. I had just recently decided that I wanted to set up a foundation at a college that would award scholarships to young women interested in pursuing the visual arts, and this was the first time I announced my intention aloud.

Dr. Suber immediately offered Saint Augustine's College and I happily accepted. The Synthia SAINT JAMES Fine Art Institute at Saint Augustine's College was soon established.

That evening Saint Augustine's College hosted an art reception at the Raleigh Museum where we sold quite a bit of artwork and I was able to donate a commission from the sales back to the college.

May 8, 2010 was the day that I received my first honorary doctorate, Doctor of Humane Letters, and it was from Saint Augustine's College. It marked my third huge honor in 2010. My first week as an Artist-In-Residence at Saint Augustine's College was in September 2010. The experience was wonderful!

On my fourth visit, April 7, 2011, I had a wonderful meeting that established an ongoing Artist-In-Residence program schedule with the Provost, Dr. Connie Allen and several other department heads. I recently completed my first two-week Artist-In-Residence on August 29, and I'll be working with my students by way of Skype through November. Isn't technology grand?

We held our first major art exhibition on October 21, 2011 and through art sales we raised monies for scholarships to the Synthia SAINT JAMES Fine Art Institute at Saint Augustine's College. On October 22, 2011, I served as the Grand Marshal in the Saint Augustine's Homecoming Parade. INCREDIBLE!

Art Marketing Tips:

140. Remain open to all possible opportunities. I couldn't have predicted or imagined that I would become so connected to a college on so many levels.

141. If you'd like to connect to colleges or universities, take the initiative. Contact them by email and regular mail. I highly suggest sending them a postcard in your package that has 4 plus images of your art on it.

CHAPTER NINETY
Sisters of Providence

In June 2010, I was commissioned by my friend Arnold Schaffer to create a very special painting. Remember, I met Arnie when he was the President of Glendale Memorial Hospital. He is now the Senior Vice President and Regional Chief Executive for Providence Health and Services, California.

In this new position he, relocated to Seattle, Washington. Arnie wanted me to create a painting that embodied and celebrated the Sisters of Providence and the people they serve. He also wanted us to release limited edition fine art prints that could be sold to generate funds for the missions.

He supplied me with books, videos and other materials to help me in my research. He also connected me with Sister Susanne Hartung, Chief Mission Integration Officer at Providence. When we connected by phone, she graciously answered all my questions.

I completed the 3-foot by 4-foot acrylic on canvas painting in early November, 2010 and it now hangs in Arnold's office in Seattle.

I'll describe it for you:
Facing the world they serve with open hearts, the images of the three foundresses symbolize the ministries the Sisters of Providence have established around the world. The countless poor and vulnerable who have been and are currently served by the Sisters are also represented. All are

enveloped by a golden light, representing the spiritual and physical healing made possible to many by the Sisters of Providence.

On the left is Mother Joseph (1856), who led the Sisters to service in the Pacific Northwest, attending to the Native Americans, the orphans and the sick. In the middle is Blessed Emile Gamelin (1843), foundress of the Sisters of Providence in Montreal. She is attending to the ministries serving elderly women and immigrants, extended today to Egypt, Cameroon, Philippines, Haiti and El Salvador. On the right is Mother Bernarda (1853), foundress of the ministries in Chile and Argentina. Here, she is attending to the ministries of education and service to orphans and families.

The sister facing us, wearing a *P* pin, represents the modern-day sister. Thus, the painting depicts the rich heritage and promising future of the ministries of the Sisters of Providence.

On the evening of Monday, May 23, 2011 at the Providence Health & Services Excellence Awards Dinner in Seattle, WA, 10 Limited Edition Remarques (fine art reproductions with original drawings on each one) of the painting, *"Sisters of Providence"* were unveiled and auctioned.

An amazing $126,000 was raised from this Live Auction for the Sisters of Providence Mission in Chile in less than thirty minutes. The amount was then matched by a corporation, for a total of $252,000. All $252,000 went to the mission in Chile.

Art Marketing Tips:

142. Always meet your deadlines and even better, complete projects before your deadline with quality work.
143. Research! Research! Research ALL projects thoroughly.

CHAPTER NINETY-ONE
The Beat Goes On

As of this writing, I'm in the process of beginning new paintings, preparing for scheduled upcoming events (giving thanks to the Divine Almighty Creator for them and you) and submitting my speaker's booking package to several colleges, universities and corporations that I haven't yet worked with and some that I have.

I'm so looking forward to the possibility of creating new architectural designs and even getting started on new books, including publishing some that I've already written, *The I Wills According to SAINT JAMES* included. Maybe a series of short stories, new children's books and how about a novel?

Check out one of my favorite songs about making it, "You're Gonna Hear from Me." My favorite rendition was sung by Natalie Wood in the film *Inside Daisy Clover*. Opening verse "Move over sun, and give me some sky…" The lyrics are by Dory Previn and the music by Andre Previn.

My favorite "Old School" song is "Ain't No Stoppin' Us Now" by McFadden & Whitehead.
Give a listen to both for inspiration.

My heart and mind are always wide open to the endless possibilities and opportunities that may seem as if they're appearing out of nowhere. But I also know for a fact that if you put it out to the universe, you will be pleasantly

surprised at what will manifest. Be ambitious…but be careful what you wish for; you just might get it. MY beat goes on and on and on…

Wishing you GOLDEN creative light & love!

Art Marketing Tip:

144. There is no such thing as "resting on your laurels" in the life of an artist and especially not in the art marketing business. If you do, your fifteen minutes of fame is destined to be even shorter.

PART TWO

Living My Dream: The 50th Anniversary Celebration

AUTHOR'S INTRODUCTION

As I sit here writing the chapters that will begin where ***Living My Dream: An Artistic Approach to Marketing*** left off, I feel HUMBLED, BLESSED and JAZZED that my 50th anniversary (1969-2019) is so near. Yet another AMAZING gift from The Creator, and I'm THANK-FULL.

I wish I could remember the exact month and day that I received my first painting commission. I would treat it as my second birthday and celebrate it each and every year. But I do remember that the temperature was mild, and the sun was shining brightly. So it must have been Spring in New York City, and I was twenty.

My hope is that these added chapters will not only bring you up to date, but that they will serve to further enlighten, encourage, stimulate and infuse the creative energies in us all.

CHAPTER NINETY-TWO
The NAACP Image Award Nomination

The NAACP Image Award is an annual awards ceremony presented by the American National Association for the Advancement of Colored People to honor outstanding people of color in film, television, music, and literature since 1967.

I completed writing *Living My Dream: An Artistic Approach to Marketing* during my second Artist-in-Residency at Saint Augustine's College in August of 2011. Then on a whim I decided to submit my book to the NAACP Image Awards.

When I returned to Saint Augustine's College that October, for an exhibition of my art, I received the amazing news from my friend and PR person Carmela D. Smith. My book was nominated in the category of "Outstanding Literary Work Instructional", and the nomination alone made me a winner as far as I was concerned.

The Process: There are NAACP committees selected to vote in each of the award categories. In the literary award categories each committee member must read and rate all of the books submitted. The six books with the highest ratings are then officially nominated.

After the nominations in all categories are announced, the vote becomes open to the over half a million members of the NAACP, and only members can vote. Books by Tavis

Smiley and T.D. Jakes were included in my category. Hands down in popularity, ***The T.D. Jakes Relationship Bible*** received the prestigious award.

The Events: All the 2012 nominees were honored at a tribute luncheon at The Beverly Hills Hotel, where we began our series of "Red Carpet" photo-opts on February 11th, which was coincidentally on my birthday.

We were treated to an evening reception the following week on February 16th at a Century City Hotel before the NAACP Image Awards Ceremony and Live TV Broadcast at The Shrine Auditorium on February 17th. Then we walked our last event "Red Carpet" at the NAACP Image Awards After Party that night.

On another note, I was thrilled to see "The Help" win top honors garnering the Outstanding Motion Picture Award, Viola Davis' Outstanding Actress in a Motion Picture Award, and Octavia Spencer's Outstanding Supporting Actress in a Motion Picture Award.

Art Marketing Tip:

145. You don't have to win to be a "winner". When an opportunity presents itself go for it. Nine times out of ten there will be benefits.

CHAPTER NINETY-THREE
The Women Who Dared: Our Legacy and Our Future

The California Black Women's Health Project is the only statewide, non-profit organization that is solely committed to improving the health of California's 1.2 million Black women and girls through advocacy, education, outreach and policy.

CABWHP's Annual "Women Who Dared" Breakfast Gala honors exceptional women who are making a difference in their careers, living healthy lives, and working to improve conditions in communities of color. Each year the CABWHP honors the women champions that advocate for the well-being of women and girls in their chosen profession.

In 2011 I was blessed to be one of the three women to be honored. The legendary "Queen of Percussion" Sheila E. and Ms. Avis Ridley-Thomas, a dynamic and highly respected Los Angeles community activist, were my fella honorees.

CABWHP is also one of the non-profit organizations that I've donated limited prints to for silent auctions to help raise funds to continue their incredible work. For "our" breakfast gala I donated a couple of limited edition prints and 50% of the final bid for a framed ***"Offering to Oshum IV"*** - Limited Edtion Giclee on Canvas. Guess who purchased "Offering to Oshum IV" - Sheila E.

Art Marketing Tips:

146. As previously mentioned, whenever possible include your artworks and/or books in events where you're being recognized.

147. Never underestimate the value of gifting your art to non-profit organizations and other worthy causes. You'll experience spiritual fulfillment as well as exposure for your art.

CHAPTER NINETY-FOUR
Saint Augustine's University

In 2012, I served my last two artist-in-residencies at Saint Augustine's College, in the Spring and Fall semesters. In August of that year the college's status would advance to university due to the leadership of President Dianne Boardley Suber.

What was particularly exciting about my four artist-in-residencies at Saint Augustine's was the "out of the box" utilization of my creativity, which included the visual, the literary, the performing, and the business arts.

In addition to lecturing, I co-taught "Writing and Illustrating Children's Books" classes with Professor Chris Massenburg, being an author and/or illustrator of 17 children's books. The students also chose affirmations from my book *The I Wills According to SAINT JAMES: Book One* to use as the inspiration for the stories they wrote in our classes.

Due to the initiative of Loretta Mask Campbell, who worked with the Honors College, 250 copies of *Living My Dream: An Artistic Approach to Marketing* were purchased, and hence became required reading for English and other classes including my "The Art of Business and Marketing".

I had the incredible experience of working with Dr. Kaye Celeste Evans, the Theatre Arts Chair, on many occasions. We screened "Emma Mae" (aka "Black Sister's Revenge") for the entire student body.

As an incentive I offered one of my limited edition prints to the first student to recognized me in the film. I played a 16-year old teen living with her family in a Los Angeles ghetto. "Emma Mae", a Blaxploitation film, was a huge hit with the students, faculty and staff.

On another occasion Dr. Evans invited me to lecture for one of her acting classes. I shared some of the realities of the profession. such as only 10% of the actors in Screen Actors Guild are working at any given time. While also encouraging them to pursue their passions.

By my last artist-in-residency I was able to add "playwright" to my Curriculum Vitae. Writing a Kwanzaa play for children with Dr. Kaye Celeste Evans had already been planned in the initial meeting where I was offered three consecutive two-week artist-in-residencies in 2011.

"It's Kwanzaa Time" - A Play in One Act by Kaye Celeste Evans and Synthia SAINT JAMES is based on two of my books: *The Gifts of Kwanzaa,* and *It's Kwanzaa Time: A Lift the Flap Book,* and the song "Happy Happy Kwanzaa" that I co-wrote with Bunny Hull. I describe my collaboration with Kaye as follows: I created the skeleton for the play and she fleshed it out.

The incredible set design included large scale panel paintings by Saint Augustine's students based on some of the paintings in my book *The Gifts of Kwanzaa.*

Dr. Evans directed the Youth Theatre Academy Production of "It's Kwanzaa Time", which made its debut to an enthusiastic audience on Saturday, December 1, 2012 in the Seby B. Jones Auditorium at Saint Augustine's University.

Art Marketing Tip:

148. Share all your work-related qualifications with colleges, universities, potential clients and future collaborators.

CHAPTER NINETY-FIVE
Coppin State University

Coppin State University is a HBCU located in Baltimore, Maryland and founded in 1900. It is a part of the University System of Maryland, and is also a member-school of the Thurgood Marshall College Fund.

My first visit to Coppin State University was in September, 2011 to unveil *"The Caregivers"*, an original painting commissioned for ARTcetra's third annual art auction benefiting Coppin State's School of Nursing.

Beverly Richards, Director of Strategic Partnerships had reached out to me with the offer, and of course I was thrilled. I was the third artist to be commissioned to create a painting for the annual event, and my best artist friend Charles Bibbs had just preceded me.

The next opportunity to visit Coppin State came the following year from Dr. Mary Wanza, Director of the Parlett L. Moore Library. *Living My Dream: An Artistic Approach to Marketing* had received the NAACP Image Award Nomination and we scheduled an "Author's Talk & Book Signing". You can easily imagine my excitement.

Art Marketing Tip:

149. Share your "GOOD NEWS" with your previous and/or potential clients and collectors, and both the social and traditional media. My author's talk & book signing was a direct result of my doing so.

CHAPTER NINETY-SIX
WORKS: Women Organizing Resources Knowledge and Service

Women Organizing Resources, Knowledge and Service was formed in 1998 by five women committed to meaningful action to help disadvantaged families and communities build lives for themselves that work.

I initially met Channa Grace, President and CEO of WORKS, at one of my gallery exhibitions in Los Angeles in the early 1990's, where she purchased one of my limited edition prints. A friendship developed and we kept in touch.

Opening in 2011, "Young Burlington" was the first WORKS development with supportive services for special needs population of transitional aged 18 to 24 year old youth. The 21 newly constructed one-bedroom apartments house young people earning no more than 25% of Area Median Income.

Channa commissioned me to create an inspirational painting that would serve to encourage and motivate the residents of "Young Burlington" to fulfill all their hopes, goals and dreams.

"Totem" is a depiction of a group of multicultural and multi-generational people grouped together to form a trunk of a tree, their roots. They are all looking upward to the brightly colored eagle soaring to the sun, moon and stars.

The painting was fabricated by Norma Montoya and Yami M. Duarte, the amazing mother and daughter artists team, into a magnificent 3-story mural on a prominent wall in the courtyard of the building.

"T. Bailey Manor" opened in August 2017 as a mixed-use development, including 46 newly constructed apartments and 2 commercial spaces in a renovated existing building. The property serves households with special needs, including formerly homeless veterans, other special needs individuals and families and persons with developmental disabilities.

I was equally honored when Channa commissioned me to create paintings (a total of 4) that would be fabricated into a 4-story mural painting, and again by Norma Montoya and Yami M. Duarte.

The title of the painting is *"We The People"*. Starting at the top, I painted bright multicolored apartment buildings with multicultural and multigenerational families and friends going to and fro. I also included a fruit vendor, a couple in wheelchairs and the slogans *Black Lives Matter* and *We The People.*

The bottom half of the painting consists of a palm tree lined luscious park adjacent to the apartment building complex filled with more multicultural and multigenerational families and friends. Tom Bailey, a noted community activist for whom the building is named, is conducting a workshop. And there's a second food vendor and the slogans *All Lives Matter* and *Building Powerful Communities Together.*

The Grand Opening Ceremony for the T. Bailey Manor Apartments included a replica of the future mural printed on a 3-story banner, which hung over a side of the building complex. The actual mural will be completed in 2019.

Art Marketing Tip:

150. Note, you don't have to be a muralist to have murals. Your painting or paintings can be fabricated into murals by professionals in the field. A list of muralists, in any city, can easily be googled.

CHAPTER NINETY-SEVEN
ACColades: A Tribute to Women Who Inspire Us

The Association of Corporate Counsel (ACC), founded as the American Corporate Counsel Association (ACCA) in 1983, is a professional association serving the business interests of attorneys who practice in the legal departments of corporations, associations and other private-sector organizations around the world.

Pamela Washington, Chief Legal Officer at Crystal Stairs, Inc., a dear friend and fine art collector, is a member of ACC. Early in 2012 she surprised me with the news that I would be receiving an "ACColades: A Tribute to Women Who Inspire Us Award".

Annually, during Women's History Month, the Los Angeles Chapter of the ACC honors two women and I was humbled to be one. I shared the honor with Carrie Broadus, Executive Director of Los Angeles' Women Alive.

First, they treated us to a meet and greet breakfast at The Farm of Beverly Hills Restaurant @ LA Live, in downtown Los Angeles, where we met the nominating committee and other invited guests from ACC a week before the event.

The ACColades Awards celebration was held at the historic Museum of Flying in Santa Monica. Tasty hors d'oeuvres and a savory selection of wines were served as we viewed the incredible exhibition of aircraft, including a replica of the Wright Flyer, prior to the awards program.

I was completely blown away when, in addition to my award, ACC donated $1,000 to the Synthia SAINT JAMES Scholarship Fund at Saint Augustine's University.

Art Marketing Tip:

151. Keep planting seeds from your heart. My continued work with Crystal Stairs must have been the catalyst for this incredible honor. A seed was first planted nearly 12 years prior when Regina Jones commissioned me to create a signature painting for Crystal Stairs.

CHAPTER NINETY-EIGHT
Cheyney University Artist-in-Residence

Cheyney University of Pennsylvania is a public, co-educational and the nation's first HBCU, founded in 1837. The university is a member of the Pennsylvania State System of Higher Education.

Cheyney had been on the top of my list of HBCUs for years. When my one-week artist-in-residence and four-week art exhibition at the Biddle Hall Gallery was confirmed I was truly elated. My art exhibition kicked off Cheyney's 2013-2014 Arts & Lectures Series.

During my artist-in-residency I led several conversational tours of my art exhibition, presented interactive lectures in classrooms, hands-on art workshops and a business of art workshop using my book *Living My Dream: An Artistic Approach to Marketing*.

Art Marketing Tip:

152. Don't be discouraged if at first you don't succeed. The first letter that I sent to Cheyney went unanswered, but I continued to reach out periodically.

CHAPTER NINETY-NINE
University of the District of Columbia Artist-in-Residence

The University of the District of Columbia is the only public university located in Washington, DC. UDC, a HBCU, was founded in 1851 and is one of the few urban land-grant universities in the country. UDC is a member-school of the Thurgood Marshall College Fund.

Right after completing my artist-in-residence at Cheyney I boarded a flight for Washington, DC. Then Interim CEO of UDC Community College, Dr. Calvin E. Woodland, had arranged for an exhibition of my art and an artist-in-residency at the University of DC.

My condensed yet energetic visit included a "Conversation with the Artist" and a reception that evening, followed by the taping of "UDC Forum: The Creative World of Synthia SAINT JAMES" with Dr. Sandra Jowers-Barber the following morning.

The 30-minute program aired several times on UDC-TV, a 24-hour educational cable station that is viewed in every major hotel, federal and congressional offices, the White House and to over 187,000 residences in the DC area. It can still be viewed on You Tube: https://www.youtube.com/watch?v=jkQM2ow86Jg&t=2s

I then conducted interactive tours of my exhibition for art classes, other students and visitors throughout the day, ending with an art reception open to the public that evening.

As with all my art exhibitions with colleges and universities, I donated 40% of the proceeds from that evening's art sales to UDC's scholarship fund. From the proceeds they were able to provide scholarship checks to two more than deserving fine art students.

Art Marketing Tip:

153. In preparation for bookings, whether it be for a college, university, an event or exhibition, make sure you are well rested and health conscious.

CHAPTER ONE HUNDRED
Harris-Stowe State University Artist-in-Residence

Harris-Stowe State University is a HBCU in St. Louis, Missouri that was founded in 1857. The university is a member-school of the Thurgood Marshall College Fund.

I reached out to Dr. Dwyane Smith, VP of Academic Affairs and now Provost at Harris-Stowe about booking a possible lecture or master class in 2012. To my delight Dr. Smith preferred a one-week Artist-in-Residence, and I would later find out that I was HSSU's first Artist-in-Residence, what an honor.

Dr. Michelle McClure, Assistant VP of Academic Affairs, took over from there and in February of 2013 I spent a week on campus. My first time ever or since in a residence hall. I was truly an Artist-in-Residence on all counts.

My suite in the Bosley Residence Hall was on a high floor and had a private bedroom, bath, dining area and kitchenette. They also provided me with a flat screen television, phone and other amenities including stocking my refrigerator.

The dining facility and a cardio fitness room was on the first floor, which proved to be perfect since the temperatures were below freezing and there was plenty of snow.

My extraordinary itinerary included multiple class visits, lectures, workshops, interactive talks and tours of my

exhibition at the AT&T Library with HSSU students and a few interactive talks for students visiting from local high schools. I even conducted an art workshop one evening at the St. Louis Museum.

In addition, there was a local radio interview, a Higher Education Channel (The St. Louis Home of Education, Arts & Culture) video interview in the AT&T Library and the Higher Education Channel taping of my keynote speech at the Emerson Performance Center which aired as "The Creative World of Synthia SAINT JAMES" in April 2014.

Here's the link to the HEC video interview: http://www.hectv.org/watch/state-of-the-arts/april-2014/14520/#synthia-saint-james

Art Marketing Tip:

154. Be prepared for the unexpected and take out some quiet time.

CHAPTER ONE HUNDRED-ONE
Tea and Conversations

Tea and Conversations, the brainchild of Sandra Long Weaver, is a networking, educational, spiritual and communications event that builds relationships among professional African American women.

The daylong seminar features breakout workshops on topics relevant to life. With origins dating back over a decade ago in Philadelphia, Sandra Long Weaver re-launched the event in Nashville, TN in April 2014.

I had the pleasure of meeting Sandra in Nashville, TN in November 2013 while I was visiting Tennessee State University as a lecturer during my art exhibition there. She interviewed me one morning on the show "Take 10 On Tuesdays" at the Tennessee Tribune, where she is the Editorial Director.

After the taping we talked about a lot of things including her desire to commission me to create a signature painting for her seminar Tea and Conversations. Early the following year she did commission me, and I was happy to return to Nashville, TN and Tennessee State University where we unveiled the original painting *"Tea and Conversations"* and the limited edition prints.

The painting is a depiction of an array of lively African American Women draped in bright clothing, wearing brilliant and flamboyant hats interacting at a tea soiree.

Art Marketing Tip:

155. Be open to possibilities. The outcome of my interview with Sandra was unpredictable and amazing!

CHAPTER ONE HUNDRED-TWO
YWCA of Greater Los Angeles

Founded in 1894, the YWCA Greater Los Angeles serves the needs of women and their families in the Los Angeles community. It is modeled after the national Young Women's Christian Association, a membership movement dedicated to empowering women by creating opportunities for growth, leadership and eliminating racism.

I received my first major award in 1997, and it was the YWCA Silver Achievement Award in the Creative Arts. Over the years I have continued to support the YWCA-GLA, usually by way of donations of my fine art reproductions for silent auctions, and later for the walls of the new building that opened in 2012.

In the summer of 2013 the desire to create a signature painting for the organization manifested, and within days I contacted then President of the Board of Directors, Eleanor Beasley. Eleanor and I are also good friends, having first met many years ago when I first became involved with the non-profit organization MOSTe (Motivating Our Students Through Experience).

MOSTe was the brainchild of Dr. Lois Frankel, author of best-selling books about women and leadership roles. In 1986, while researching families and education, Dr. Frankel found that young girls from underserved backgrounds were missing out on key information about higher educational and career opportunities. I'm so honored that *"Empowerment"*, the signature painting that I created, is still being used as MOSTe's logo.

My signature painting proposal was approved, and now it was time for me to soak up all the inspiration needed to create the painting *"PowerFULL: YWCAGLA"*.

On the morning of August 24, 2013, Eleanor graciously guided me on a tour of several of the program facilities such as the South Bay Empowerment Center, the Compton Empowerment Center, and the Los Angeles Job Corps Center.

I first painted the letter Y which is made up of multiple figures of women and girls that reach the top left and right corners of the painting meeting in the middle of the painting, then continuing straight down to the bottom edge of it.

The Job Corps students and graduates fill in the area between the top center of the Y. Then clockwise from the right of the Y: representations of women in empowerment centers, 24/7 help-line, and the support of counselors, doctors and other women.

From the bottom left of the Y and upwards towards the center there are representations of infant and child care services and after school children's services, with senior citizens services just above. I painted a bright blue sky at the top of the painting to symbolize the promise of a rich, bountiful future filled with unlimited opportunities.

After I completed the painting we enjoyed a private unveiling just for the executive staff and board of directors on December 12, 2013 at the Compton Empowerment

Center. Officially on May 14, 2014 we unveiled the painting at the annual Phenomenal Woman of the Year Awards at the Omni Hotel to the delight of all in attendance.

I must applaud the YWCA-GLA for their ingenious utilization of their reproduction rights to *"PowerFULL: YWCAGLA"*. In addition to the hand-signed and numbered limited edition prints, artist proofs and remarques of the painting, there are *PowerFULL: YWCAGLA"* umbrellas, coffee mugs, and notecards.

Then, according to level of your membership, incentive gifts could be chosen from the merchandise listed above. I repeat, INGENIOUS!

Art Marketing Tip:

156. Be prepared. Take some time out to write a generic proposal letter for commissioned artwork and save it to your document file for future use. Make sure to include some basic terms of agreement (i.e. 50% deposit), and a list of prices according to the canvas.

CHAPTER ONE HUNDRED-THREE
The Pepperdine Black Alumni Council Keynote

The Black Alumni Council (BAC) provides scholarships, advocacy, support and networking opportunities for Black students and alumni. BAC creates an identity and an enhanced sense of cohesiveness and recognizes the achievements and contributions that Pepperdine Black alumni have made in community, nation and universe.

I was honored to serve as the Black History Month keynote speaker for the BAC in 2014, at the invitation of Charles J. Franklin, President of BAC and American Honda Motors Executive.

Exhibiting a selection of my artworks, added a vibrant ambience, and enhanced my interactive presentation. The Black Alumni Council also benefited, because I was able to donate 40% of the proceeds from my art sales to their scholarship fund.

Art Marketing Tip:

157. Develop a "Win-Win" Attitude. "Win-Win" is a frame of mind and heart that constantly seeks mutual benefit in all human interactions.

CHAPTER ONE HUNDRED-TWO
Bennett College: The First HBCU Inaugural Commission

Bennett College is a private four-year HBCU for women located in Greensboro, North Carolina. It was founded in 1873 as a normal school to educate freed slaves and train them as teachers.

Congresswoman Alma Adams, aka Dr. Alma Adams, introduced me to Bennett College as a speaker in 2001. It was the same year that she curated my one-woman exhibition at the African American Atelier, which she co-founded, and I was awarded the Key to the City of Greensboro, NC. At that time Dr. Adams was also a professor of art at Bennett College and the director of the Steele Hall Art Gallery.

My association continued with Dr. Adams over the years with several speaking engagements at Bennett College and another one-woman exhibition at the African American Atelier in 2010.

A new chapter began in 2013 when I first spoke with Dr. Rosalind Fuse-Hall, then president of Bennett College. "Inaugural Paintings for HBCU Presidents", Dr. Fuse-Hall was the first to commission me to create one. The effects of her brainstorm couldn't have been foreseen or imagined.

I visited Bennett College that November on a mission to soak up all the inspiration I would need to create the painting. In my research I first read the entire history of

Bennett College, including traditions and ceremonies, and the significance of the stained-glass art in the chapel, the Bearden Gates and the Bennett Bell.

Next, I focused on the students who were attending Bennett, casually interviewing those that I met on campus, or privately in their dorm rooms, and others that were in classes that I visited. I asked why they had chosen to attend Bennett College, and what made the college special to them. "The feeling of sisterhood and family" was most often the answer.

When I returned home creatively jazzed, I simply plunged into painting *"Bennett Belles"* and remained knee deep in paints until I completed it.

As scheduled, I returned to Bennett College during Dr. Fuse-Hall's inaugural week and enjoyed participating in several of the events. First, "The Belle Ringer Luncheon", where I was included in the elite group of honorees and a scholarship was presented in my name to Amra Marshall. During the luncheon Dr. Fuse-Hall and I unveiled the painting *"Bennett Belles"* and the hand-signed open edition prints to the delight of all those in attendance.

That evening we held the official opening reception of my Solo Art Exhibition in the Steele Hall Art Gallery, where *"Bennett Belles"* was first revealed to the public. Dr. Fuse-Hall again played my "Vanna Black", which she had done at the luncheon, as I described all the elements in the painting.

The painting *"Bennett Belles"* is an assemblage of all I soaked during my research visit to Bennett College. Close to center of the painting I placed Dr. Fuse-Hall celebrating her as a gift to the college and her beautiful and genuine spirit. I then surrounded her with students embracing her in welcome forming the shape of a bell with her at the top/center, the crown of the bell.

At the top of the painting from the 1930's I painted the first four Bennett College graduates, The Bennett Four, and members of their families looking up at them on stage. Then below them a couple of Bennett alumni dressed in white on either side of Dr. Fuse-Hall and a couple of incoming Belles dressed in white.

What an honor and pleasure it was for me to attend Dr. Rosalind Fuse-Hall's Investiture Ceremony, the VIP Luncheon that followed and the Inaugural Gala, all joyous and heart-warming memories.

I continued my dual role as artist-in-residence into the following week co-teaching art classes with Professor Harry Swartz Turfle, an amazing artist. Then off to do what? You'd never guess.

Art Marketing Tip:

158. Just a reminder of the essential importance of research in all our creative endeavors.

CHAPTER ONE HUNDRED-THREE
Alabama State University: HBCU Inaugural Commission

Alabama State University, founded in 1867, is a HBCU located in Montgomery, Alabama. ASU is a member-school of the Thurgood Marshall College Fund.

Upon completion of my first inaugural painting *"Bennett Belles"*, in utter excitement I began sharing the news of this added component to the scope of my artistic offerings.

Dr. Bernadette Chapple, then Associate Vice President at Alabama State University, presented my inaugural painting proposal to the newly appointed and first female ASU President, Dr. Gwendolyn E. Boyd, and as Dr. Fuse-Hall would say "She came on board the train."

The painting titled "Opportunity Is Here: ASU" would be the second painting that I created for Alabama State University. The first, *"Enlightenment: USA"* was unveiled in November 2012 at the re-opening ceremony for renovated Levi Watkins Learning Center.

Ironically, I would unveil Dr. Boyd's painting and the hand-signed and numbered limited edition prints on September 4, 2014 at her inaugural luncheon, nearly three weeks before I unveiled *"Bennett Belles"*.

In my research for this painting I prepared a list of questions for Dr. Boyd for our telephone meeting. I researched her life and achievements online, downloaded photos of her, watched videos of her preaching since she's an ordained minister, and I enjoyed watching her dance to "Happy" (by Pharrell Williams) with ASU's hornet mascot in a video on youtube.com.

Several of the elements that were important to Dr. Boyd are included in the painting *"Opportunity Is Here: ASU"*. Her focus on STEM is evidenced by two science students in lab coats, and the international appeal of ASU is represented by students from countries such as South Africa, Nigeria, Asia and Brazil.

In the painting Rev. Dr. Boyd is donning her Doctor of Divinity scarlet hood, and the Delta Sigma Theta Sorority, in which she served as the national president for a four-year term, is depicted.

Art Marketing Tip:

159. While interviewing a client regarding commissioned artwork be certain to jot down the answers to all your questions. Then, immediately following the conversation, type or legibly write down all the information you acquired for reference.

CHAPTER ONE HUNDRED-FOUR
Florida Memorial University:
HBCU Inaugural Commission

Florida Memorial University is a private HBCU coeducational university in Miami Gardens, Florida founded in 1879. FMU is a member institution of the United Negro College Fund.

The morning after my artist-in-residency ended at Bennett College I was airborne, flying to Miami, Florida for the unveiling of my third inaugural painting ***"Women Lifting Their Voices"***.

My friend (a HBCU advocate and Cheyney alumni) Vicki L. Redmond, contacted me with the news of Dr. Roslyn Clark Artis' rapidly approaching inauguration as the first female president of Florida Memorial University. The timing was very tight, but I immediately reached out to Dr. Artis.

In the wee hours of the next morning I received a phone message from Dr. Artis and she sounded just as excited as I was about creating a painting to celebrate her inauguration. When I called her we discussed her vision for the painting and most all the other details.

I had approximately four weeks, (actually only three weeks when you factor in my Artist-in-Residence at Bennett College), to create the painting, have it custom framed,

complete the proofing, printing, the signing and numbering of the 1000 limited edition prints, and then arranging for the boxing and shipping of all to Miami Gardens, Florida from Los Angeles, California.

But what a joy it was to be knee deep in paints commemorating the inauguration of my third female president of a HBCU.

Dr. Artis included the unveiling of *"Women Lifting Their Voices"* in the inauguration program just preceding her investiture, and we unveiled the painting together front stage center.

The painting, *"Women Lifting Their Voices"*, is a celebration of multicultural women, young and seasoned, that have lifted their voices in pursuit of their individual goals, realized and achieved. Dr. Artis is depicted top center being celebrated and embraced by all for her triumphs and her deep-rooted spirit of service to others.

The twenty women in the painting include a recent college graduate, educators, a clergywoman, business women, a vocalist, FMU student, Delta Sigma Theta sister (Dr. Artis' sorority), and more.

Art Marketing Tip:

160. When it comes to deadline crunches it's best to first map out a schedule plan. Include your actual painting time, printing and signing, framing and shipping (all aspects), and then notify all your vendors well in advance.

CHAPTER ONE HUNDRED-FIVE
Simmons College - Eileen Friars Leader-in-Residence

Simmons College, established in 1899, is a private, women focused undergraduate college and private co-educational graduate school in Boston, Massachusetts.

"World renowned visual artist will be on campus during the week of March 23rd, 2015. Visual artist and author Synthia SAINT JAMES will spend the week of March 23-27, 2015 at Simmons College as the Eileen Friars Leader-in-Residence, lending expertise in visual arts leadership to Simmons students, faculty, and staff, and the Boston community."

January 20, 2015 - News Announcement from the College of Arts and Sciences, Simmons College

The Eileen Friars Leader-in-Residence Program was established to draw on the experiences of women who have distinguished themselves in their professions. Prior leaders include former Supreme Court Judge Bette Uhrmacher, Artist Robin Holder, Educator and Activist Jill Iscol, Ed.D, and film director Abigail Disney.

Chosen to serve as a "Leader-in-Residence", what a humbling recognition. I have to admit that I had never thought of myself as a leader and had to learn to digest that fact.

On the evening of my first day Dr. Renee T. White, then Dean of the College of Arts and Sciences who had honored me with this appointment, Simmons College President

Helen G. Drinan, Eileen Friars, Simmons College Trustee who established the program, and Marianne Lord, Vice President of Advancement and I enjoyed a delectable meal at an incredible waterfront restaurant, Legal Sea Foods.

I stayed at the Marriott Residence Inn just about a mile from the college. The snowy chill in the air was exhilarating and the abundance of geese amusing on my daily walks to and from Simmons.

The schedule of classes, events and workshops, expertly planned, were both thought-provoking and imaginative. In fact, two of my lecture topics, "My Sheroes: Edmonia Lewis, Katherine Dunham & Lena Horne (The Arts & Civil Rights)", and "The Healing Art of Synthia SAINT JAMES", were both specifically drafted for presentation at Simmons College.

The first was for a Women and Gender Studies class, and the second for a workshop I co-taught with Dr. Raquel Stephenson, a Board Certified and Registered Art Therapist (ATR-BC). Titled "Painting for Healing and Self Expression", it included presentations by us both followed by a hands-on art workshop that I facilitated.

During my Leader-in-Residence I had a concurrent solo exhibition of my art on campus, and I lead several interactive tours for students, teachers, staff, and the general public.

I maintained designated office hours for private student consultations where we'd discuss such things as career goals and aspirations or use the technology afforded us to

research potential work-related possibilities. I also taught a "Business of Art" workshop.

I led an "Inspirational Tour" for visual artists, photographers and writers in which we walked together through the streets of Boston soaking up inspiration, while capturing photos and taking mental notes.

Our last stop was the wonderful Harriet Tubman House, where we were immediately led on a personal and enlightening tour. We then took an exceptional time-out to just sit, share thoughts and creatively bond before we headed back through the invigorating drizzling rain.

In the auditorium of the Massachusetts College of Art and Design one evening, Dr. Renee T. White moderated a panel titled "Art, Media & Politics" in celebration of the 50th anniversary of the Selma Voting Rights March.

The panel featured four African American leaders including Executive Producer and Host of WCVB-TV's show City Line, Karen Holmes Ward; Senior Editor at Penguin Random House, Stacey Barney; Founder of the Roxbury International Film Festival, Lisa Simmons and me.

After I led my last interactive tour of my art exhibition, a farewell dinner was hosted on campus. The guests included members of the Board of Trustees, Leadership, Faculty, Staff and Alumnae. There was a short program, introduced by Dr. Renee T. White, in which I briefly spoke and answered questions about my art and career.

Several of my artworks sold during my exhibition, and I was thrilled to donate 40% of the proceeds to a Simmons College scholarship fund. The Joy of Giving is immeasurable!

"A leader is passionate, open-minded, creative, adventurous, and able to embrace their mistakes and humility. SAINT JAMES is the epitome of those characteristics."

Ahalia Persaud, Simmons College Class of 2015

Art Marketing Tip:

161. Accepting new and somewhat challenging situations is a definite growth opportunity. My experiences as a "Leader-in-Residence" enhanced my abilities as a lecturer, teacher and counselor for students.

CHAPTER ONE HUNDRED-SIX
Dartmouth College

Dartmouth College is a private Ivy League research university in Hanover, New Hampshire established in 1769. It is the ninth-oldest institution of higher education in the United States and one of the nine colonial colleges chartered before the American Revolution.

I landed at Logan International Airport in Boston again nearly five weeks after my residency at Simmons College. I was en route to Dartmouth College to facilitate a book cover design workshop. I rushed to board the next scheduled Dartmouth Coach and made it, arriving on campus three hours later.

It was the first day of spring-like weather in Hanover, New Hampshire, and Dartmouth's Green was filled with students catching the late afternoon rays of the sun, soaking up the warmth. And I wanted to join them. So as quickly as possible I checked into my room at the Hanover Inn, Dartmouth's on campus boutique hotel, and hit the Green for my first magical walk on campus.

I rose early the next morning in time to witness a beautiful sunrise and venture out for an extended walk, a self-guided tour of the massive self-contained township that is Dartmouth.

My full day on campus included a conversational lunch date with two Dartmouth students at the PINE Restaurant, an upper end restaurant located in the lobby of

the Hanover Inn, where we sat outside on the patio facing the Green. Followed by my workshop on book cover design with collage art attended by students, faculty and staff.

Then to cap off the day, dinner with the faculty and staff of the African and African American Studies Department just over the bridge in Norwich, Vermont at the Norwich Inn. Delicious!

At that dinner a scholar-in-residence mentioned "The Temple Murals" and I got up in the wee hours to make sure to view the eight-panel mural painted to honor the principles exemplified via the life of Malcolm X, titled "The Temple Murals: The Life of Malcolm X".

The Dartmouth Afro-American Society commissioned New Jersey based artist Florian Jenkins to paint the murals for the walls of Cutter Hall's dormitory common rooms in 1972. MAGNIFICENT, AWE-INSPIRING and SOUL-FELT!!!

Formerly called the Cutter Hall, the dormitory is now the Cutter/Shabazz Hall, and the building houses both the Afro-American Society and the Shabazz Center for Intellectual Inquiry. An important note: Malcolm X lectured at Dartmouth College and stayed in a suite in Cutter Hall just weeks before he was assassinated in 1965.

Dr. Gretchen Holbrook Gerzina, then Chair of the African and African American Studies Department, invited me to Dartmouth. What an honor!

I had the privilege of meeting Dr. Gerzina several years prior when she was the Director of Africana Studies at Barnard College and had brought me in as a speaker.

Art Marketing Tip:

162. The gift of opportunity presents itself whenever we travel. Make a point of seeing and experiencing all possible, even on short work-related trips.

CHAPTER ONE HUNDRED-SEVEN
Stillman College: HBCU Inaugural Commission

Stillman College, originally Tuscaloosa Institute, is a HBCU located in the West Tuscaloosa area of Tuscaloosa, Alabama that was founded in 1876.

Late in 2014 I was contacted by an executive staff member of Stillman College expressing interest in commissioning me to create an inaugural painting for their president, Dr. Peter E. Millet. This would to be my fourth HBCU inaugural painting and the first for a male president.

After some preliminary research on Stillman College and preparing a list of questions, I had a scheduled phone meeting with Dr. Millet. He supplied me with all the other details and the photos that I needed to begin the painting.

Elements in the painting "From Excellence to Eminence" have a more personal touch, Dr. Millet wanted me to include his wife (a member of the AKA Sorority), daughter (student at Spelman College), mother (a member of the Delta Sorority) and his father (a minister) in addition to the many aspects that relate directly to Stillman College.

“From Excellence To Eminence” was unveiled during the festivities that led to Dr. Millet's Installation on March 13, 2015.

Art Marketing Tip:

163. Capturing the client's vision, so very important in all commissioned artworks. Therefore, our responsibility is to listen very well, and when in doubt to ask questions.

CHAPTER ONE HUNDRED-EIGHT
Harris-Stowe State University Inaugural Commission

Harris-Stowe State University, a HBCU, is a public university in St. Louis, Missouri. The university is a member-school of the Thurgood Marshall College Fund.

Dr. Michelle McClure and I began unofficially talking about the possibility of my creating an inaugural painting for Harris-Stowe State University during my artist-in-residency there in February 2014, soon after I completed my first inaugural painting *"Bennett Belles"*.

When the Board of Regents appointed Dr. Dwaun J. Warmack as the university's new president, effective July 14, 2014, ideas began percolating and Dr. McClure spearheaded the proposal.

I was so jazzed when this, my 5th inaugural commission and second male president, came to fruition. I had already bonded with the students, faculty and staff of Harris-Stowe State University.

Completing my research, I prepared a list of questions for Dr. McClure and a list for Dr. Warmack, which I discussed with them both separately by phone.

With Dr. Warmack, who at 38 was one of the youngest presidents of any four-year institution in the country, I discussed his motivations and goals as president, and he titled the painting *"Called To Serve: Inspiring Change"*, his so relevant motto. And Dr. McClure and I discussed

other detailed aspects of the painting that were more focused on the university.

Description of *"Called To Serve: Inspiring Change"*: (Top to Bottom)
HSSU male students - Alpha Phi Alpha Grad, Kappa Alpha Psi student, student graduating with honors. These young men are already following Dr. Warmack's leadership and life examples by reaching their life goals and ambitions through higher education. They symbolize Dr. Warmack's commitment to increasing the number of male students attending and graduating from HSSU.

Centered below them is Dr. Warmack in full Doctoral regalia being welcomed, honored and embraced as the 19th President of Harris-Stowe by the male and female students above and below him in the painting.

There are a couple of female students representing the AKA & Delta Sororities and Dr. Warmack's wife and daughter greeting a couple of multicultural children from the HSSU Clay Education Center.

Close to bottom center a male HSSU student wearing a "Black Lives Matter" hoodie emphasizing HSSU's commitment to Civil Rights & Social Justice, as well as HSSU students, staff and faculty's involvement in peaceful demonstrations following the shooting of Michael Brown and the Ferguson Case.

I unveiled *"Called To Serve: Inspiring Change"* on stage during Dr. Warmack's Investiture Ceremony on April 15,

2015. The limited edition prints were released shortly after.

Art Marketing Tip:

164. Only when appropriate, include subliminal or obvious visuals in your commissioned paintings to emphasize current events. In *"Called To Serve: Inspiring Change"* Civil Rights and Social Justice was very relevant to HSSU.

CHAPTER ONE HUNDRED-NINE
North Carolina State University Artist
and Scholar-in-Residence

North Carolina State University is a public research
university located in Raleigh, North Carolina. It is part of
the University of North Carolina System and is a land, sea,
and space grant institution.

In July, 2015 I received the warmest invitation via phone
from Toni Harris Thorpe, Program Coordinator of the
African American Cultural Center at North Carolina State
University, to be their Fall Artist and Scholar-in-
Residence.

I was amazed, honored and thrilled even before I knew that
my residency would include a three-month solo exhibition
of my art in the African American Cultural Center Gallery.

I traveled to Raleigh, NC on a Sunday and was treated to a
fantastic sea food meal at a local restaurant. On Monday
my full itinerary began with a morning tour of the center
and my first look at my exhibition followed by a private
interactive tour that I led for the invited faculty, staff and
student guests.

Monday evening a "Dessert & Discussion with Synthia
SAINT JAMES" was held at the Turlington Arts
Residence Hall for students living in NCSU arts
community. After which we had dinner with a select few
of the art students at a traditional Japanese restaurant, a
delightful new experience for most.

The official opening of my exhibition was held on Tuesday evening with an Art Talk, Q&A and Reception. That night a group, including a few friends that I'd worked with at Saint Augustine's University, joined us for a casual dinner celebration.

On Wednesday evening I concluded my residency by presenting my interactive "The Business of Art Workshop" for NCSU's College of Design, which was attended by a large group of the students and the faculty.

Art Marketing Tip:

165. Prepare for all your presentations well in advance. You will feel confident and relaxed while enjoying the whole experience.

CHAPTER ONE HUNDRED-TEN
Kentucky State University 130th Anniversary Commission

Kentucky State University is a public university in Frankfort, Kentucky and HBCU founded in 1886 as the State Normal School for Colored Persons.

Dr. Karen W. Bearden, Chairperson of the Board of Regents at Kentucky State University, was intrigued by *"Bennett Belles"* my first HBCU inaugural painting when she saw it at Bennett College.

Dr. Rosalind Fuse-Hall, then president of Bennett College, initiated our connection and the rest is herstory. My first HBCU anniversary painting was set to bloom.

Within a few weeks, after phone conversations with Dr. Bearden, Sonia Sanders, Assistant to the President and Dr. Raymond M. Burse, Interim President, I was en route to Frankfort, KY. It would be my first visit to Kentucky State University and the State of Kentucky.

The primary purpose of my visit was to gather historical information and inspirational materials, both written and visual, which would enable me to create a painting that would truly capture and celebrate the university's 130-year history onto a 48x36" canvas.

My itinerary was arranged to provide all that I needed and began with an illuminating discussion with Donald Lyons, Trustee of the Kentucky State University Foundation, and concluding with historic tours of the campus and community.

I was also there to interact with the students, faculty, staff, alumni and the community which began with a "Conversation with the Artist", where I was welcomed by the Frankfort Tourist Commission with a basket filled with eclectic gifts. There was an art symposium and a forum for the Women of Kentucky State University for which I spoke.

During my two full days in Frankfort, Kentucky, which is the capital city of the Commonwealth of Kentucky, I was completely surprised and blown away by the honors bestowed upon me.

They included recognitions by both The House of Representatives and The Senate during their regular sessions, and I received the highest honor awarded by the Commonwealth of Kentucky, that of Kentucky Colonel.

My return trip to Kentucky State University was on May 17, 2016, three and a half months later. I had completed the painting *"Onward & Upward"*, had it custom framed, and signed and numbered the 1000 limited edition prints, artist proofs and remarques. All had been shipped well in advance, awaiting my arrival.

We announced the official unveiling of *"Onward & Upward"* on WLEX-TV's Great Day Live on the morning May 18th, unveiled the painting that afternoon in Kentucky State University's Student Ballroom and again during the 130th anniversary dinner at The Lancaster at St.

Clair that evening. The following day the painting was prominently displayed in the Rotunda of Kentucky's State Capitol Building.

"Onward & Upward", top to bottom, focuses on the early years of KSU depicting teachers between 1886 and the early 1900s, a man in a checkered cap representing KSU's working dairy, farm and classes. Just below, a man in overalls represents the building and construction trade taught at KSU, and then Jackson Hall, the landmark first building on campus.

The painting continues through the 1920's-30's then to the 40's-60's and includes a female basketball player, a couple going to a homecoming dance, and members of the 1970's champion basketball team Travis Grant #33 and Elmore Smith #25, who both turned professional for such teams as the Los Angeles Lakers, are then prominently depicted.

The multicultural and international aspect of KSU are manifested towards the bottom of the painting, along with the Greek fraternities and sororities on the campus of KSU. The painting concludes with then Interim President Burse surrounded by KSU graduates following a commencement ceremony.

"The painting is OUTSTANDING and a testament to the time she (Synthia SAINT JAMES) spent meeting with alumni, researching the archives and talking with faculty and students."

President Raymond M. Burse

Art Marketing Tip:

166. Develop a good work ethic. As a direct result of my good work ethic/traits: emphasis on quality, dependability, dedication, productivity, respectfulness, determination, and professionalism, I came highly recommended and received the KSU painting commission.

CHAPTER ONE HUNDRED-ELEVEN
USPS Kwanzaa Forever Stamp

"What an incredible honor! I was first commissioned to create the painting for the first Kwanzaa stamp in 1996, which was released in 1997 as a 32 cents stamp, followed with releases as a 33, 34 and 37 cents stamp with 318 million before it was retired. Now a brand-new Kwanzaa Forever Stamp, nearly 20 years later, celebrating the 50th anniversary of the Kwanzaa holiday. I was so jazzed, and thrilled.

"In my first Kwanzaa stamp, I highlighted the sixth day of Kwanzaa, the celebration of the principle of 'Kuumba' creativity and the Kwanzaa feast. The emphasis of this stamp is 'First Fruits', and the affirmation for both spiritual and material abundance in our lives.

The African-American woman, adored with symbols of the Ndebele Tribe on her earring and on her dress, is offering for all to partake from her overflowing bowl of first fruits in celebration of the Kwanzaa holiday."

Excerpt from Synthia SAINT JAMES First Day of Issue Speech, October 1, 2016, Charleston, SC

When I first received the email regarding the possibility of licensing one of my existing paintings or perhaps creating a new painting for another Kwanzaa stamp I was in disbelief. I replied by phone immediately for clarity and found that discussions were well underway. That was on February 3, 2015.

In June I received the USPS contract commissioning me to create a new painting, and I was teamed with Greg Breeding, a fantastic graphic designer. The new Kwanzaa stamp was scheduled for release in 2016.

The First Day of Issue dedication ceremony was held in conjunction with the MOJA Art Festival celebrating African-American and Caribbean arts in Marion Square in Charleston, SC.

Art Marketing Tip:

167. Give your creative ALL to every project large or small. It may come back to haunt you in a positive way.

CHAPTER ONE HUNDRED-TWELVE
AARP Commission and Metro Rail Line

AARP (formerly American Association of Retired Persons) is a United States based interest group whose mission is "empowering people to choose how they live as they age."

"Synthia SAINT JAMES has been sharing her gift with the world for decades. Her latest work of art is larger than life and many Los Angeles commuters see it daily on the Metropolitan Transportation Authority's Expo Line that runs between Downtown Los Angeles and Santa Monica Beach.

The project is a collaboration between the MTA and 50 and older advocate group AARP, whose representatives asked the artist to put into pictures her interpretation of riders' responses to questions about what improvements they'd like to see in their communities.

This particular AARP outreach, a part of their ongoing "Portraits of Community" project, included those in the mostly African-American communities of Baldwin Hills, Crenshaw and Ladera Heights."

ART IN MOTION: Artist Synthia SAINT JAMES' work featured on EXPO Line Cars, Los Angeles WAVE Newspapers (September, 2016)

I was introduced to Jennifer Hopson, the Associate Director for Multicultural Outreach for AARP Los Angeles through a mutual friend Barbara A. Perkins, Founder of Sisters At The Well, Inc. and Co-Founder of International Black Women's Public Policy Institute.

Jennifer was interested in commissioning me to create the second painting in the "Portraits of Community" project, and I was thrilled with the possibility! We met, excitedly discussed details, and IT WAS ON!!!

The press and the social media campaign began on May 10, 2016. "AARP in Los Angeles is thrilled to be partnering with famed painter and true age disruptor Synthia SAINT JAMES on our latest "Portraits of Community" project...Help Paint the Picture with Your Input." And the community responded with answers to the question: "What would make L.A. an even better place to live?"

The majority answered: new affordable and housing, parks, better transportation and accessibility for the handicapped and elderly, and fresh fruits and vegetables. And I incorporated them all into the 20x60" acrylic on canvas painting that I created and titled "Our Community".

Once I completed the painting and had it professionally scanned for high resolution reproduction, Tamika Quillard, graphic designer extraordinaire, began work on the designs for the application of my painting (via art wraps) to the Metro Train cars.

The official unveiling of "Our Community" was held in Union Station at the Ticketing Concourse in Downtown Los Angeles on October 4th in conjunction with the First Annual Older Adult Transportation Expo, just three days after the First Day of Issue of my 2016 Kwanzaa Forever Stamp. My Expo Train ran its route from August through November, 2016, and I've been conjuring up an airplane ever since.

Art Marketing Tip:

168. Verbalize your ambitions and they just might manifest.

CHAPTER ONE HUNDRED-THIRTEEN
"Origin of The Dream" Commissioned Painting Unveiling

Amazing things often happen when least expected. Here's one example. During my Artist and Scholar-in-Residency at North Carolina State University in 2016 I had the pleasure of meeting Dr. W. Jason Miller, author of ***Langston Hughes and American Lynching Culture*** and ***Origins of the Dream: Hughes's Poetry and King's Rhetoric***.

Dr. Miller is also a Professor of English at NCSU, and he joined the first tour of my art exhibition that I led in the African American Cultural Center Gallery in September 2015. Ironically two paintings inspired by the life and legacy of Dr. Martin Luther King, Jr., were included in my exhibition, and they called to him.

They were "The Dream" which celebrates the 50th anniversary of Dr. King's delivery of the speech "I Have A Dream" in Washington, DC, during the March on Washington for Jobs and Freedom, and "How Long Not Long" which celebrates the 50th anniversary of the Selma to Montgomery March for voting rights.

A couple of weeks later when Toni Harris Thorpe (AACC) and I spoke, she informed me of Dr. Miller's interest in commissioning a painting that would be inspired by his book ***Origin of the Dream*** and created for his forthcoming documentary film "Origin of the Dream". And I reached out to him immediately.

My research began with a wonderful conversation with Dr. Miller, reading his book, and other materials and links that he sent that historically documented the unexplored intersections of two of the twentieth century's foremost African-American visionaries: poet Langston Hughes and civil rights leader Dr. Martin Luther King, Jr.

We would unveil the painting, ***"Origin of The Dream"***, together on Saturday, September 17, 2016 at James B. Hunt Jr. Library, Duke Energy Hall on NCSU's campus, nearly one year to the day of our first meeting, during the Experiencing King Events.

The Painting Description:
Bottom, left to right, Dr. King, Simple (the Black fictional character found in many of Hughes's short stories, who's also known as Jesse B. Semple), and Langston Hughes walking together down 125th in Harlem, NY in the 1960's.

The APOLLO Theater marquee (with THE DREAM highlighted in blue lettering) is seen prominently at the top left of the painting under the blue sky. Then to the right and top of painting filling in all the other areas, a mixture of Harlem men and women locals and visitors including a jazz musician and an African drummer.

Art Marketing Tip:

169. Be proactive. Good fortune happens when preparation meets opportunity.

CHAPTER ONE HUNDRED-FOURTEEN
Tuskegee University Artist-in-Residence

Tuskegee University is a private HBCU located in Tuskegee, Alabama about a 45-minute drive from Montgomery, AL. It was established by Booker T. Washington in 1881. Tuskegee University is the only HBCU designated as a National Historic Site, and it was home to George Washington Carver and to World War II's Tuskegee Airmen.

Being invited to be an Artist-in-Residence at the iconic Tuskegee University is beyond words. Couple that with an exhibition of my art at the Legacy Museum, a museum that houses artworks by such renowned artist as Edmonia "Wildfire" Lewis (one of my sheroes), Henry Ossawa Tanner, and William H. Johnson in their collection.

Permanent exhibitions in the Legacy Museum include The Hela Cell, which celebrates the life of Henrietta Lacks. She was the African American woman whose cancer cells are the source of the Hela Cell Line, the first immortalized cell line and one of the most important cell lines in medical research.

My Artist-in-Residence began on February 15th and ended on 19th in 2017. Staying on campus at the Kellogg Hotel and Conference Center, in the spacious and elegant Presidential Suite, was an added treat.

The first morning found me exploring the 5,000-acre campus on a self-guided tour, absorbed in the spirits of history. The Oaks, Booker T. Washington's Home, which I would visit on a guided tour; the George Washington Carver Museum; "Lifting The Veil of Ignorance", the Booker T. Washington bronze monument by Charles Keck depicting him lifting the veil of ignorance off his people; and the graves of Booker T. Washington and George Washington Carver in the small cemetery, the National Historic Sites.

My residency included lecturing in TU's Lyceum Series, "A Talk with the Artist: Dr. Synthia SAINT JAMES", which was a joy because of the engaged and responsive students.

Immediately following, we adjourned to the Legacy Museum for the Opening Reception and Artist Walk-through of my exhibition "The Creative World of Synthia SAINT JAMES". There I was able to interact with several students on a more personal level while they shared their creative works (visual and written) with me.

On my last day I taught a master painting class, my first "Paint & Sip", for 45 participants including students, faculty, staff, community, visitors, children and Mrs. Shemeka Johnson (then First Lady of TU).

The delicious "Sip" included non-alcoholic beverages consisting of fruit juices, teas, coffee, and water, and a full brunch of hot cheesy grits, eggs, turkey sausage and bacon, quiche, croissants, fruits, and desserts.

I chose *"Abundance"*, a colorful painting depicting three generations of a Black family wearing African attire, the mother, who is holding a large bowl overflowing with fresh fruits and vegetables, is encircled by her loving family.

The participants painted their interpretations of the painting on 8x10" canvases with acrylic paints and brushes. The class was scheduled for two hours and many stayed on for four hours, while others took their paintings and art supplies to their homes or dorms to complete.

Art Marketing Tip:

170. Try to learn something new or useful from each of your events. Music was played during the "Paint & Sip" and it proved to be relaxing for the participants. I will be including music in my future art classes and workshops.

CHAPTER ONE HUNDRED-FIFTEEN
Kentucky State University Artist-in-Residence

I traveled back to Kentucky State University as an Artist-in-Residence on March 20, 2017 to conduct an extensive three-day master class, a collaborative art project with students.

Each student was required to create a 18x18" painting based on the theme "The Creative Arts" in the style of their choosing. The paintings would then be assembled together, collage style, with the 18x18" painting that I created for framing.

As with Tuskegee University's "Paint & Sip", we ordered the following art supplies for my master classes: 18x18" stretched canvases (we used a smaller size canvas at TU), Chromacryl Acrylic Essentials' set of 12 colors in 16oz bottles (black, brown, cool blue, cool red, cool yellow, green, orange, purple, warm blue, warm red, warm yellow and white) for the students to share, acrylic flat brushes/academic synthetic flat sizes 2,4,&6 (one set for each student), plastic palettes (one for each student), 8-12oz sturdy plastic cups for cleaning brushes (one for each student), non-photo blue pencils for drawing onto canvas and erasers (one for each student), rolls of paper towels for cleaning brushes, pencil sharpeners, and rulers (to share).

After a preliminary class meeting, where I introduced the project and the intention, we convened daily in a large area of the Student Center, which was set up just for us with

long flat tables and chairs for painting. My master class hours were flexible, students could work on their paintings any time between 9am-4pm, enabling students to participate between their other classes.

The incredibly imaginative and magnificent paintings created by the students are a true testament to gifting them with complete freedom of expression, with no boundaries or grade consequence.

Art Marketing Tip:

171. When teaching an art class or workshop gift your students with complete freedom of expression.

CHAPTER ONE HUNDRED-SIXTEEN
Occidental College - Artist-in-Residence

Occidental College is a private liberal arts college located in the Eagle Rock neighborhood of Los Angeles, California. Founded by clergy and members of the Presbyterian Church, it is one of the oldest liberal arts colleges on the West Coast.

We are most often our best promoter. I say this because I've found it to be so very true in my life. I continuously research and reach out for opportunities, bookings, commissions and more, and I owe the honor of my Artist-in-Residence at Occidental College in part to just that.

I emailed a letter and my "One Page" to Erica O'Neal Howard, Senior Associate Dean of Students at Occidental, and she immediately forwarded it to Deena Selenow, Director of Oxy Arts, the College's campus-wide hub for the arts. In less than two months I was experiencing an amazing Artist-in-Residency.

I was made aware of the fact that "OUR" President Barack Obama had attended and graduated from Occidental College (Class of 1983) and had lived on campus.

"I started reading more seriously and more deeply about social justice issues and became more engaged with issues of social justice."

Barack Obama

Occidental was the place where Obama made his first political speech, on February 18, 1981 (at the Anti-Apartheid rally), as part of a movement to persuade the Occidental Board of Trustees to divest the College of its investments in South Africa. Historic to say the least!

On the first day of my residency (March 29, 2017), I presented my interactive lecture "My Sheroes: Edmonia Lewis, Katherine Dunham & Lena Horne (The Arts and Civil Rights)". Later I enjoyed an intimate and informal luncheon conversation with 15 female students majoring in the arts.

The last day consisted of an Artist Meet & Greet, my Lecture Presentation and Book Signing and Reception. From selected fine art reproductions of my paintings, we sold prints and posters, and I donated 40% of the proceeds to Occidental's scholarship fund).

Art Marketing Tip:

172. Show your appreciation by giving back.

CHAPTER ONE HUNDRED-SEVENTEEN
enCourage Kids Foundation - Times Square Billboard

enCourage Kids Foundation empowers kids facing health challenges to lead their most awesome lives through cost-free family outings and uplifting hospital programs.

Their programs reach kids facing a variety of health issues, from those receiving chemo treatments in a clinic to those who live with a chronic illness that may not be visible. What they all have in common is that they deserve the same opportunities to laugh, to play, and to have fun, whether they are being treated in the hospital or living with their struggles at home.

I was introduced to Marc Brogdon, President of N2U Creative Marketing Group, by my dear friend and attorney Karen E. Pointer in April, 2017. At that time Marc was producing "Ripley's Believe It or Not! Presents Breaking Barriers", a benefit for enCourage Kids. It featured martial artist Leif Becker breaking over 12,000 boards in a 24-hour period on May 11th.

Artists for enCourage Kids Foundation was another component of the fundraising campaign. 10x12" original paintings on pine wood boards were created by the featured artists. The paintings reflected various barriers or issues facing society today, as well as works of hope and inspiration.

As one of the featured artists, I created and donated three of the paintings that were auctioned off on May 12th, the

proceeds of which benefited Creative Arts Therapies in hospitals.

The preceding promotional campaign included a Times Square Billboard five stories high and above McDonald's. Photos of each of the featured artists, holding up one of their paintings for the auction, continuously flashed. The credit on my billboard photo read - Synthia SAINT JAMES, Artist/Visual Architect/Author.

After the amazing success of both campaigns, I began thinking of other feasible possibilities for fundraising. One materialized through the combined efforts of Lailah Greene, my New York art dealer and friend, Producer Marc Brogdon, and Michele Hall-Duncan, Executive Director of enCourage Kids Foundation.

The Synthia SAINT JAMES Private Art Salon in New York City's SoHo was presented on October 26th, 2017, and Lailah Greene's exquisitely framed SAINT JAMES' originals and fine art reproductions graced the walls of the spacious and immaculate suite.

"The people in the room know her (Synthia SAINT JAMES) not just as an artist, but also as a friend, poet, Hollywood businesswoman, and are supporting her art salon to benefit the enCourage Kids Foundation."

"While visiting New York, SAINT JAMES also spent time with children with blood cancers and other blood disorders at Mount Sinai Kravis Children's Hospital. SAINT

JAMES guided them through an art therapy exercise where they studied the postal stamp she designed for Kwanzaa in 1997 and came up with their own stamp ideas."

Excerpts from "Synthia SAINT JAMES Talks Her Love of Color and Healing Through Art" by Melanie Eversley for NBCBLK, published on October 29, 2017.

After the art therapy exercise, I was the featured guest on Mount Sinai KidZone TV. KidZone TV produces live programming three times a day, seven days a week, for pediatric patients and families. The programs are broadcast throughout the hospital on a dedicated channel.

The host of the show and I guided the bedridden children and their families through the same art therapy exercise we presented earlier. We also enjoyed responding to their comments and questions sent via phone calls and text messages.

Art Marketing Tip:

173. Post all your upcoming exhibits and events on social media and send invitations and press releases to traditional media via email. Melanie Eversley contacted me in response to my post on Linkedin.com resulting in her wonderful interview and published story.

CHAPTER ONE HUNDRED-EIGHTEEN
The Synthia SAINT JAMES Collection - VIDA

VIDA'S STORY - www.shopvida.com

"VIDA's story is that of the rich, interconnected world we live in. The story of contemporary life and mindful, global citizenship. We are a global partnership of co-creators, from a designer in Paris, to a producer in Karachi, Pakistan, and a consumer in San Francisco."

VIDA provides the opportunity for artists worldwide to design their own (line) collection of clothing, accessories and home decor from tops and scarves to candles and tapestries without paying a fee.

The artist uploads, positions and designs each product of their choosing online from high resolution files of their artworks and receives a royalty of 10% of net sales quarterly based on gross international sales.

I became a VIDA designer in 2016. The company's commitment to help drive social change for artists and makers (art factory workers) through literacy and empowerment programs greatly influenced my decision as well.

Art Marketing Tip:

174. Here's a chance to make money while you sleep. But only if you follow through by promoting your collection daily, especially in the beginning. Post photos of the

products in your collection with direct links on social media and in emails to family, friends and your collectors.

CHAPTER ONE HUNDRED-NINETEEN
The National Association of African American
Honors Programs: "Honors Mindset"

The National Association of African American Honors Programs is a national academic organization that began in 1990. The association provides honor students with opportunities to network, debate, compete academically and present scholarly research each year at its annual conference.

I was introduced to Dr. Leah Creque-Harris, then president of the National Association of African American Honors Program, by Loretta Mask Campbell in 2017 via a phone conference call. To my delight we made preliminary plans for a commissioned painting, my 11th HBCU painting.

I unveiled the painting, *"Honors Mindset"*, during NAAAHP's 26th Annual Conference in Atlanta, Georgia at Morehouse College during the Awards Gala, where to my surprise, I was honored with the "Legacy Keeper Award" on November 10, 2017.

Three students graduating with honors grace the top of the painting dressed in full regalia including the honor symbols of cords, stoles and a medallion. Below them I've portrayed an array of honors students in various fields including robotics, medicine, space technology, the visual arts, dance and music, and students studying in the library.

During the four-day conference the limited edition prints of *"Honors Mindset"* were sold to help raise funds for the continued empowerment of NAAAHP's honor students

and programs. The prints are available for purchase on NAAAHP's website - www.NAAAHP.org.

Art Marketing Tip:

175. Stay connected, opportunities often reappear through past alliances. Loretta Mask Campbell and I first met at Saint Augustine's University.

CHAPTER ONE HUNDRED-TWENTY
30th Annual MLK Unity Breakfast, Rocky Mount, NC

"On November 27, 1962, Martin Luther King, Jr. stood not on the vast mall of Washington, DC, but in a small gymnasium at Booker T. Washington High School in Rocky Mount, NC. He delivered a speech about the importance of race relations and civil rights. While this speech - given before 1,800 people - was not the size or scope of the landmark Washington, it did contain a familiar phrase: I Have A Dream."

Rocky Mount Review, January 3, 2015

Dr. W. Jason Miller was the keynote speaker for the 29th Annual MLK Unity Breakfast in Rocky Mount, NC, and many months later I would learn that he had recommended me for the following year, monumental.

The theme for the 30th Annual MLK Unity Breakfast was "The Unfinished Work of a Dreamer", which I incorporated into my speech. But my emphasis was on sharing lesser known facts about Dr. King's brilliant life, so in my research I read *The Autobiography of Martin Luther King, Jr.* by Clayborne Carson.

It is important to note that Dr. Clayborne Carson is an African-American professor of history at Stanford University, and director of the Martin Luther King, Jr., Research and Education Institute. Since 1985 he has directed the Martin Luther King Papers Project at the request of Coretta Scott King, and that the narrative of his

book *The Autobiography of Martin Luther King, Jr.,* is entirely based on Dr. King's own words.

My speech was interactive and included the large screen projections of four of my paintings inspired by Dr. King's life and legacy, titled *The Dream"*, *"How Long Not Long"*, *"Origin of The Dream"*, and *"MLK: Called To Serve"* which was inspired by my research for the speech. The audience's participation and interpretations of the paintings were phenomenal.

The auditorium was darkened, except for the stage, so I didn't know that I had received a standing ovation until I was told two days later, so humbling. My first speech in honor of Dr. King fell on his birthday, January 15th, AMAZING!

"Synthia SAINT JAMES' irrepressible enthusiasm and remarkably humble personality became the catalyst for an unforgettable commemoration of Dr. Martin Luther King, Jr.'s birthday in Rocky Mount, NC. She dramatically engaged the audience throughout her illuminating presentation in ways that made her vivid works accessible to all ages, especially those who do not consider themselves art aficionados.

In this birthplace of Dr. King's dream, every person left inspired by one of today's most sought-after painters as her many works featuring Dr. King convey both the history and humanity of a man now better understood as a result of her meticulous brushwork. Dr. SAINT JAMES' speech still resonates like an arrow trembling in the target."

Dr. W. Jason Miller, author of *Origin of the Dream: Hughes's Poetry and King's Rhetoric* and Professor of English, North Carolina State University, Raleigh, NC

Art Marketing Tip:

176. Step outside of your comfort zone, challenge yourself, take risks and you'll realize your full potential.

CHAPTER ONE HUNDRED-TWENTY-ONE
Commonwealth Honors College, UMass Amherst

The Commonwealth Honors College provides a diverse community of academically talented students with extensive opportunities for analysis, research, leadership and community engagement within a nationally recognized research university, the University of Massachusetts Amherst.

I was so pleased to hear from Dr. Gretchen Holbrook Gerzina, champion of my previous visits to Barnard College and Dartmouth College and now Dean of Commonwealth Honors College, and to receive her invitation to UMass Amherst.

UMass Amherst, the Commonwealth's flagship campus, is a nationally ranked public university offering a full range of undergraduate, graduate and professional degrees. The 1,463-acre campus has a total student population of over 30,000.

I was housed at the Hotel UMASS and what fascinated me most on campus was the W. E. B. Du Bois Library, the largest academic library in the world. The 28-floor library is home to African American scholar, writer, and activist W. E. B. Du Bois' memoirs and papers, the archives established by former African America Chancellor Randolph Bromery (1971-1979).

In celebration of Black History Month and in my honor Dr. Gerzina hosted an informal luncheon where I enjoyed

mingling with CHC faculty and staff. Later, after an extensive interview with two students, I facilitated a collage workshop for about 50 participants including students, faculty, staff and 4 small children on the evening of February 6, 2018.

A collage is a technique of composing a work of art by pasting various materials on a single surface, and I gave my class the complete freedom to use their imaginations and to just have fun in the process.

Provided materials included construction paper in various colors, numerous photographic magazine cut-outs, color markers and pencils in various colors, rulers, scissors, glue sticks and collage paper boards.

The fulfillment I felt was two-fold, the expressive and creative beauty of all the collages and the therapeutic calming effect the workshop had on all the participants. The icing on the cake was the feedback from the students requesting more such workshops.

Art Marketing Tip:

177. Leave a positive and lasting impression and opportunity will knock again and again.

CHAPTER ONE HUNDRED-TWENTY-TWO
Bishop State Community College Foundation

Bishop State Community College is a state-supported, open-admission, urban community college located in Mobile, Alabama. The College is a HBCU that's part of the Alabama Community College System. The Bishop State Community College Foundation provides academic and scholastic support for the college through their annual scholarship gala.

Through the recommendation of foundation board member Voncile Cunningham, the BSCC Foundation selected me as the 2018 Foundation Gala Keynote Speaker, an honor in itself. By the event planning's end an exhibition of art was included at the History Museum of Mobile, astounding!

I had the privilege of first meeting and working with Voncile nearly fifteen years ago during a Delta Theta Sigma Sorority fundraiser in Bloomfield, MI that combined the literary and visual arts. Dr. Cynthia Jacobs Carter's fascinating and historical book *Africana Woman: Her Story Through Time* was featured along with an exhibition of my art.

When my plane landed in Mobile Voncile was there to pick me up. Having dinner together was on our agenda. When we walked into Southern National, a five-star restaurant with a chic Southern charm, to my surprise a large table was reserved and several guests had already arrived including Dr. Reginald Sykes, the president of the college.

I lectured at Bishop State Community College the following morning in an auditorium filled to capacity with students. I engaged them visually by playing a video featuring some of my art and career accomplishments, and from that point on the lecture was a "conversation". Just what I had hoped for.

After some photo opts and selfies with the students I was treated to a Dora Franklin Finley African-American Heritage Trail: Step on Bus Tour.

"Journey through history so rich and thorough and a time when European and African explorers first landed on the shores of the Gulf Coast and began populating this land we now know as, The United States of America. You will travel through time, more than 300 years back in history and brought into the modern age today's diverse community."

Art May, President of DFFAAHT

My private tour was narrated by Karlos Finley, brother of the late Dora Franklin Finley, Founder of DFFAAHT and motored by Eric Finley, their cousin. It couldn't have been more intriguing or memorable.

Africatown, Africatown/Plateau Graveyard, Creole Firehouse #1, Bettie Hunter House, National African-American Heritage Archives and Museum, Slave Market, Davis Avenue (the area settled by African Americans) that was later renamed Dr. Martin Luther King Avenue and the

mural depicting the Clotilda (the last slave ship to enter the United States by way of Mobile, AL in 1860), were for me the most thought-provoking.

Edra Elise Finley, MAMGA's Mardi Gras queen in 2013, and BSCC Foundation Board member, then conducted me on an incredible tour of The Mobile Carnival Museum. One of the exhibits in the museum featured Edra's exquisite Mardi Gras gown and robe. Did you know that Mardi Gras was first celebrated in Mobile, AL in 1703?

A little respite later and the VIP reception was underway at the History Museum of Mobile, where I led the assembled group on a private tour of my art exhibition. The GALA reception began at 7pm and the guests mingled while sipping wine and helping themselves to tasty hors d'oeuvres and the delicious buffet - enjoying live music.

I thoroughly enjoyed interacting with the audience during my keynote speech. But what followed caught me completing off guard, a proclamation from the City Council declaring March 1, 2018 "Dr. Synthia SAINT JAMES Day" in Mobile, AL, and a "Key to the City of Mobile" presentation, overwhelming!

The event concluded after a short tour of my art followed by the sales and signings of purchased framed and unframed limited edition giclees on canvas and other fine art reproductions. I donated 40% of the proceeds to Bishop State Community College's Scholarship Fund.

Art Marketing Tip:

178. Devise and plan your events well in advance and in minute detail. Due to the ingenuity of Voncile and Edra the Foundation's 2018 Gala is now a "How can we top this?" event.

CHAPTER ONE HUNDRED-TWENTY-THREE
Benedict College Inaugural Painting Commission

Benedict College, a HBCU located in Columbia, South Carolina was founded by a woman in 1870, Mrs. Bathsheba Benedict. On June 30, 2017 the Board of Trustees unanimously appointed Dr. Roslyn Clark Artis as the 14th President of Benedict College, earning her for the second time in history, the distinct honor of serving as the first female President of a collegiate institution in the United States.

Her inaugural week-long celebrations, themed *"From Our Founding...To Our Future"* began on April 8, 2018. The following afternoon Dr. Artis, her daughter Jocelyn and I unveiled the inaugural painting, "From Our Founding To Our Future", to rousing applause at the In Her Footsteps Luncheon.

The monumental week culminated on April 13th with Dr. Roslyn Clark Artis' Investiture and Installation Ceremony, The BESTofBC Gala and the establishment of The President's BESTofBC Scholarship Fund.

When I received this message from Dr. Artis on November 4, 2017, "I wondered if you might be interested in creating a new piece for my inaugural here (Benedict College)?" I replied, "YES YES YES!!! It would be an HONOR & I'm already OVER THE MOON with EXCITEMENT!!!"

"From Our Founding To Our Future" aka "First Family Benedict College" - My Eleventh HBCU Painting - Description:

Middle to Bottom Center: Dr. Artis centered between, left to right, her older son and her husband and, lower left to right, her younger son and her daughter. The First Family is surrounded by students walking in different directions but obviously welcoming and embracing them.

Top of Painting left: Mrs. Bathsheba Benedict with two students/teachers, female in white and male in suit and bow-tie, from the 1870's. A modern day female student, just below the female in white, is bridging the past to the present with foot prints (shoe prints) on her book bag leading from Mrs. Benedict to Dr. Artis.

Top Center left to right: a modern-day female student in gold, Darryl Izzard in a purple choir robe (Benedict Choir Leader), current male and female honor students/graduates.

The hashtag #TheBESTofBC is on the backpack of a female student, and a male student is wearing gold with "Tigers" (the mascot) on his jacket collar. The painting highlights the school colors of gold and purple (in various shades) throughout.

Dr. Artis, who previously served as the first female president of Florida Memorial University, and I had unveiled her first inaugural painting "Women Lifting Their Voices" during her Investiture and Installation Ceremony as President of FMU on October 3, 2014. And they say that lightning doesn't strike twice.

Art Marketing Tip:

179. Stay focused yet open. The difference between impossible and possible lies in your self-determination.

CHAPTER ONE HUNDRED-TWENTY-FOUR
The Beat Goes On & On

As I sit writing the last chapter of *Living My Dream: The 50th Anniversary Celebration,* I'm filled with immense and heartfelt gratitude. I'm living my life in creative abundance and savoring every moment.

Numerous dates are already booked for "The Creative World of Synthia SAINT JAMES: 50th Anniversary Celebration Tour", and I've been awarded several new painting commissions.

Bishop Vashti McKenzie's "SELAH Leadership Encounter for Women 2018", Dallas, TX; the Black Spectrum Theatre, Queens, NY; Kentucky State University, Frankfort, KY; and Tom Joyner's 20th Anniversary Fantastic Voyage Cruise are included in my list of confirmed tour bookings.

I'm well into writing my first novel, *Hyacinth*; Art Therapy workshops/speaking engagements are now a part of my agenda; I'm working on my new Tibetan series of paintings between commissions, and I'm wide open to new, exciting and challenging opportunities.

I leave you with lyrics from Lena Horne's "Believe In Yourself", as only she could sing it.
In GOLDEN Creative Light & Love...

If you believe
Within your heart
You'll know that no one can change
The path that you must go
Believe what you feel
And know you're right because
The time will come around
When you'll say it's yours

"Believe In Yourself"
Words and Music by
Charlie Smalls
(from *The Wiz*)

RECAP OF ART MARKETING TIPS

1. Don't feel shy! Let people know you're an artist. Most people are very intrigued by artists and will help you spread the word, which will often lead to more sales.

2. Research is very important to the pricing of your artwork. Find out what other artists who are at the same level in their careers are asking and receiving for their artwork.

3. Documentation is of the utmost importance. Have the paintings you plan to release as fine art reproductions or for licensing opportunities scanned professionally onto a CD as tiffs and jpegs at a color lab specializing in artwork. You'll be able to get more work based on the work you've already done, not to mention you'll gain access to the many licensing opportunities available for existing artworks.

4. Store the CD's in a safe place. I'd suggest either looking into renting a safe deposit box at a bank or at least investing in a small to medium size fireproof safe to keep in your home. You can buy a safe at most office supply stores or online.

5. The bandwagon effect can occur at exhibitions, too. Once a person purchases a piece of artwork, one of their friends, a family member or just another person at the exhibit will want to purchase something for themselves.

Often, they'll want the same piece that the person just purchased. If this is a fine art reproduction with multiple copies, let them know you have others available. If this is an original painting, you can offer to create a similar or special commissioned painting for them.

6. Money in the bank is essential for your peace of mind on all levels so always maintain a savings account. Whether you're planning a location move or an investment in your art career, including publishing a limited edition, it's always good to know that you have some money to fall back on.

7. If your time doesn't permit you to work on a project immediately, recommend scheduling it for a later date. The client will respect your talents more for the demand on your work.

8. Showing samples will certainly help promote sales. Always have up-to date visuals of all your artwork to show potential buyers.

9. No matter how many other jobs you may have to work in your lifetime, always look for something in them that you can apply to your true passion your art.

10. Take advantage of all the time you have and all the time given to you to work on your art.

11. Seek out and make the most of every opportunity.

12. Look for exhibition possibilities everywhere. In your community's libraries, schools, churches, office buildings and centers. Exposure is a must for artists. You'll never know who may see, buy or commission you once they have seen your artwork.

13. If you are truly dedicated to your art, be sure that you don't choose any means of financial support that would dilute your creative passion. You don't want to lose it.

14. We all need encouragement and the ability to self-motivate. We now have the endless possibilities of the internet. I had to subscribe to art magazines and trade magazine, including Art Business News, Art World News and Decor. You can now go online and find some of the trade magazines and numerous other websites for visual artists, including free websites.

15. Don't overlook listed opportunities to participate in juried shows nationally and internationally. First, however, do some research on the gallery, museum or venue to verify their credibility.

16. Our invitations for memberships were hand delivered to the offices or homes of the upper echelon. They were hand printed and calligraphed on exquisite hand rolled scrolls of parchment and tied with bright ribbons. From managing this process, I learned that a creatively alluring invitation most certainly will yield a much more positive response and audience, which of course, can be done on a much smaller budget.

17. When you invite collectors or potential collectors to visit your studio or gallery, make them feel at home and very welcome. Have a variety of hot and cold beverages to offer, including wine. In addition, provide some simple snacks, including cheese and crackers, mixed nuts and cookies.

18. Know that the more comfortable and at home your clients feel, the more receptive they will be to buy or commission a work of art.

19. Realize that your artwork will be the "a la Rousseau mural," so give collectors and potential collectors the special treat of sharing the inspirations behind each one of your works on display and if possible, let them visit the studio or area where you create your artwork.

20. On a creative level, your art is your art. Never let someone's opinion dampen your spirit or change your focus or direction.

21. On the professional side, research is essential. Before even considering contacting a gallery, find out what kind of artwork they exhibit and what artists they represent. Then inquire about what their policies are for reviewing art. You can find out a lot by visiting their website for the answers. I don't suggest calling them by phone, a letter of introduction or inquiry would be better. Be sure to include your business card or a postcard which includes a sample of your artwork.

22. Never visit a gallery with the intention of showing your artwork or portfolio without a prearranged appointment. To do so would be very unprofessional and downright rude.

23. Press clippings are great art marketing tools. Writing and submitting one for yourself is quite acceptable.

24. Make a list of your neighborhood and local newspapers to keep on hand for easy reference of national and international art publications that may be interested in your story. You can find these lists through research on the internet.

25. Even if you're exhibiting with a gallery or museum, it is good to find out how the press is being handled. You may be able to add to the press coverage. Remember to cover as many bases as possible; you never know what interest you might spark.

26. All experiences are useful in marketing art. For instance, many people were thrilled with the paintings that my trip inspired because they knew that I had actually visited the places I painted. In a sense, they had traveled vicariously with me through my paintings.

27. Maintaining good time management skills is one of the most important factors of success. Create a schedule that works for you.

28. Remaining focused on your goals is essential.

29. I can't overemphasize how important it is to let people know that you're an artist. The possible positive outcomes are limitless.

30. Never make a nuisance of yourself by pushing your art at your job. You will more than likely completely turn people off and possibly lose your job.

31. Become part of or establish a small group of artists and share information and exhibition opportunities. I know you'll find quite a few visual art groups online.

32. Don't take the rude behavior of others personally. You will encounter all kinds of people during your life and career; some will be very positive and unfortunately, some will be negative.

33. We have to keep reinventing ourselves, to some degree, throughout our lives and careers. In this case, it meant that I needed to find another way to generate income to remain creative.

34. Again, I was able to learn new skills that would be easily applied to marketing my artwork: putting together a professional package/media kit.

35. I learned the importance of having business cards, personalized stationery and a good general presentation to maximize interest in my artwork and sales.

36. I changed the signature at the end of my correspondence from "sincerely" to "cordially," following the example of Bob's pitch letters to clients.

37. Again, I'm emphasizing the importance of letting people know you're an artist. If Perkie didn't know, I would have never received the commission.

38. Host home/studio shows and invite collectors and future collectors.

39. Look for other non-traditional venues to show and sell your work.

40. Find and or create your signature style or styles. It will become your trademark and art collectors and enthusiasts will recognize your art on sight.

41. We're back to the bandwagon effect: Richard Pryor's purchase made others think, *If Richard Pryor purchased five of her paintings, her art is worth collecting.*

42. Before selling an original painting, be sure that you have a high-resolution digital file, a tiff and a jpeg scanned.

43. Keep your copyright.

44. Make your clients feel relaxed and welcome. Never push sales.

45. Be sure to take care of your financial business. Always have a signed letter of agreement or contract with whomever you allow to exhibit your artwork.

46. It is very important for you to have a permanent mailing address and a telephone number where people can always contact you. I've always used my post office box address and I've always made use of an outside answering service for my business and advertising purposes.

47. There are several ways that you can get your art published as reproductions, investors are just one of them.

48. You can also invest in yourself by using the money made from selling an original to self-publish it in a limited or open edition reproduction.

49. We all have champions: they may be family, friends or business acquaintances. Also establish and cherish your other possible support groups and be open to learn from all. Mentors come in a variety of packages.

50. Never underestimate the power of giving. Donate your artwork to worthy causes. Remember, it's not necessary to donate originals; art reproductions are more than welcome. Just imagine the possible exposure your artwork could receive.

51. Read every single line of commission agreements and contracts. It's even better if you consult with someone in the legal profession or with an attorney. Maintaining your copyright is not only important but can be very lucrative when it comes to licensing your artwork later.

52. It doesn't hurt to hone in on your speaking and people skills. I have found that the general public and your possible collectors really want to hear from you.

53. Fully use all opportunities. If I hadn't shared the fact that the painting was available for purchase, I may have never had the privilege of adding Alice Walker's name to my list of collectors.

54. Have business cards printed with your paintings or artwork on the card. People tend to hold on to these "mini-prints."

55. It always pays to research your projects well, especially the commissioned ones. What may seem like minor details or facts are crucial to the authenticity of the end-product.

56. Talent is not the only ingredient necessary in becoming a successful artist.

57. Consider taking a public speaking or acting class if you think it will help you feel more relaxed in front of an audience, interviewer or at your art receptions.

58. Let people know that you're available for the various jobs you may be interested in.

59. When you're hot, keep the fires burning. Make the best possible use of all your successes.

60. Self-publishing is now bigger than ever. I've created book covers for several self-published authors, including Barbara A. Perkins, Khaleedah Mohammad and Marcia Dyson. Self-publishing is another market to tap.

61. Don't forget the business of art. Have your attorney or legal consultant go over the details of all contracts before agreeing to a verbal or written contract. Your primary concern should be keeping the copyright to your artwork and to the text if you've written any of the books.

62. Be open to all artistic possibilities. Don't limit your creative self.

63. Research other possible art markets for your work.

64. Generate mailings and work will find you.

65. Don't overBOOK yourself. I learned that 3 books in one year is over tasking yourself and therefore, very stressful. There are generally eighteen to thirty paintings per picture book. What was I thinking? I didn't know.

66. Cover yourself well in all your licensing agreements. There may be times when you may need to terminate them.

67. Be sure to copyright all your work, including any writing you create in conjunction with an art project.

68. Licensing your art images can be very lucrative, so research the possibilities.

69. Try to attend at least one International Art Licensing Expo to get the feel of the magnitude of licensing opportunities available.

70. Subscribe online to License Magazine at www.licensemag.com to learn more about the market.

71. Develop a fitness routine to keep your mind and body healthy. This will also enhance your creative flow.

72. Create a blog and share your good news.

73. Save all the press you receive from magazines and newspapers and scan them to create documents you can email.

74. Update and list all your accomplishments in your biography.

75. Submit your artwork to the Art in Embassies Program. It's simple and so much could come from it. It's a wonderful addition to your resume. Visit http://aiep.state.gov for submission guidelines.

76. Make your contact information easily accessible. To keep my privacy, I always use my Post Office Box and an inexpensive outside phone service.

77. Creating a website is highly importance. If you can't afford to have one built right away, at least list yourself on other sites that feature artists. Many of these websites have levels of membership they don't charge for. Here are four worth checking out: www.fineartamerica.com, www.absolutearts.com, www.fineartworld.com, and www.blackartinamerica.com.

78. Send your PR package to everyone you work with, even if you already have the job or commission. They'll learn more about you and there may be more opportunities with them in the future. You can easily send it to them by email.

79. Again I'd like to emphasis our need for people skills, including public speaking and conducting interviews on television and radio, by phone or in person.

80. Expect your art career to include traveling and choose the mode of travel that suits you. I've always traveled by air, primarily with American Airlines.

81. Enroll in your airline's frequent flyer program. You can redeem your business mileage earned for your personal travel and vacations.

82. Develop your own best working schedule. In the creative arts, so much relies on self-discipline.

83. Include some quiet time and exercise time for yourself to reduce the stress and to remain healthy above all.

84. Don't ever underestimate the importance of accuracy. Research all your projects.

85. Don't give up. Be persistent in pursuing projects you really believe in.

86. Whenever possible, work with people you really feel good about working with, especially in the book publishing field.

87. There are endless possibilities for licensing when you keep the copyright to your artwork.

88. Develop reliable and good working relationships with everyone you work with or for. With a good reputation, even more work will be the reward.

89. Recognition awards can lead to so much more. You can't exactly go out searching for these awards or be prepared for them. I certainly wasn't. But your artwork has an impact on more people than you'll ever know.

90. I learned that show-woman/-man ship is another important element of successful art marketing.

91. Always be opened to alternative ways of working on a project.

92. There can be great creative and monetary profit in working with nonprofit organizations and foundations.

93. Press is an incredible art marketing tool. So again, I emphasize the importance of sending out press releases and blogs for all your exhibits, events and on your accomplishments. You can even list events on many of your local television station's websites and on all your websites.

94. There are quite a few publicists that will work with you on a per-event or per-hour basis.

95. There are all kinds of artists; don't be intimidated by your degree of education. Some of the most famous and revered artists were self-taught.

96. Keep your doors wide open to opportunities. I've found that speaking engagements will help generate art sales, commissions and invitations for more speaking engagements.

97. If you're interested in submitting your artwork to television shows, first research the show by watching an episode or two. See if you feel that your work would fit in with the series theme, characters or decor.

98. Make a list of some possible shows and then send a package to the set designer. Generally, you'll find the name of the set designer in the show's credits or by calling the studio where it's taped.

99. Consider that on some shows, you may not be paid for the use of the art so always submit paintings that you have art reproductions of. Then sell or lend them a reproduction.

100. Learn more about set decorators by visiting the Set Decorators Society of America's website http://www.setdecorators.org.

101. Make a list of organizations you would like to work with or currently work with and make a proposal involving your art or the use of it. Remember, an existing image (painting) could very well be used instead of creating a new one.

102. Two heads are better than one. When you decide to venture into fundraising for nonprofits be sure to send the person in charge of fundraising your proposal. Schedule to meet with them, if possible, at your studio or home where they will be surrounded by your artwork. Together you can create an even stronger proposal to offer to the heads of the organization.

103. Some of the organizations that ask for silent auction donations are very open to receiving a percentage of the final sales price of your artwork. I suggest offering them a donated commission of thirty to fifty percent. This is another way to not only give but to receive.

104. There are and always will be numerous new markets and opportunities for your art such as activity books. Someone is always looking for an illustrator to bring their writings to life. Many opportunities can be found by doing research on the internet. Always be open and willing to expand.

105. Whenever possible try to include a small exhibition and sale of your artwork at your award events. With nonprofit organizations, I always donate a percentage of sales to their scholarship or community programs.

106. If an organization requests use of your artwork on their invitations or brochures for an event, ask if it would be possible to have some of your art at the actual event available for sale and offer them a small commission.

107. Remember that awards are important because they recognize your achievements and because they introduce your artwork to others that may not know you or may not know how to contact you.

108. Be gracious and humble. No one enjoys the company of someone who believes that the world revolves around them.

109. If you have an interest in public art, contact your local and national public art resources such as the cultural affairs department. You will usually be able to add your name to their list of artists or submit an application to be added to their mailing list for public art notices.

110. Don't be afraid to challenge your creative ability. You'll create something you may never have imagined.

111. Isn't it interesting how one project led to another nearly fourteen years later? I truly believe that whatever we put out there will come back to us in some shape or fashion.

112. Again, I must emphasize the importance of creating a website. One of the lawyers at Gibson, Dunn & Crutcher went online looking for artists whose artwork included diversity. My 150-foot airport mural is titled *"Diversity"*, therefore, I was one of the first considered for the job after they visited my website.

113. Go for whatever your creative heart desires.

114. Create IT and make IT happen!!!

115. Again, make sure to get high-resolution, reproduction quality scans done of your artwork. I have hundreds of reproduction transparencies stored. But with the new technologies, I now have my paintings scanned professionally onto a CD.

116. Find a safe place to store your transparencies and disks and make sure that you can retrieve them on short notice. I had only one day to find my transparency for *"Legacy"* and I had to ship it to the ad agency FEDEX overnight to meet their deadline.

117. When negotiating a licensing contract that includes appearances and travel, be sure to factor in an additional fee.

118. As an artist, give back by aligning yourself with causes dear to you or to nonprofit organizations.

119. Look into the possibility of creating something for your church or place of worship. Also, let your friends and coworkers know you're available for fundraisers.

120. It's impossible to foresee the outcome of all our investments, but we never know unless we try. Some of the artists did quite well financially on the cruise.

121. Make the best of any situations. I made several new friends that became collectors and became reacquainted with an old friend.

122. My investment in Tom Joyner's cruise paid off after all. My art was seen by Nabeeha on board and that led to later sales. You never know what the future outcomes may be.

123. ***"Of Many Colors"*** was existing art. Again, I highlight the importance of owning your copyright and of having a suitable transparency or scanned CD for reproducing your art.

124. You are considered a part of your art, so always be prepared to "meet and greet."

125. Submit your artwork to Advertising Agencies for review.

126. Keep your mind wide open to new opportunities. I never could have imagined that I would create awards.

127. Take full advantage of websites such as www.YouTube.com. Upload and broadcast videos of your events, interviews and promos.

128. Look for ways that you can help your local community or communities through your artwork. Example: Teaching an art class for children or young adults.

129. You'll find inspiration everywhere if you're open to it.

130. When you travel, safely experience as much of the culture as possible. It can be so inspiring.

131. Immediate follow up is essential. If I wasn't prepared to follow up, this wonderful licensing partnership would have never happened. Establish a FEDEX or UPS account in your name or business name. You will be able to put together whatever is needed and call in for a pick up for overnight delivery and you'll be able to pay later.

132. In some cases you'll need some upfront money or you can use a credit card to have your color lab transfer your art into whatever form needed by the person or company you're working with. Just be sure to invoice them for reimbursement as soon as possible. Some companies may take thirty days to generate a check back to you.

133. Learn from experiences and plan accordingly.

134. Set some goals for yourself. One of my goals was to connect to Historically Black Colleges and Universities and to develop relationships with them.

135. When creating artwork that will be used on merchandise for a client, always remember to include a provision in the contract to receive a percentage of the prints or a number of the products. Or if you're creating for a for profit organization, include a provision that you'll receive a royalty on sales.

136. In this day of "plastic," you most certainly need to be able to charge to credit and debit cards. Pay Pal is good, but for impulse buyers, credit card terminals - stationary or wireless - are much better.

137. Always have a supply of your professional business cards with you. You never know who you may meet.

138. Be sure to get copies of all videos and photos from your events. They are a great marketing tool that can be used on your website and uploaded to YouTube. I have a couple of links to my YouTube videos and a link to my website in the signature area of my email.

139. At these business networking events, politely introduce yourself to the people around you.

140. Remain open to all possible opportunities. I couldn't have predicted or imagined that I would become so connected to a college on so many levels.

141. If you'd like to connect to colleges or universities, take the initiative. Contact them by email and regular mail. I highly suggest sending them a postcard in your package that has 4 plus images of your art on it.

142. Always meet your deadlines and even better, complete projects before your deadline with quality work.

143. Research! Research! Research ALL projects thoroughly.

144. There is no such thing as "resting on your laurels" in the life of an artist and especially not in the art marketing business. If you do, your fifteen minutes of fame is destined to be even shorter.

145. You don't have to win to be a "winner". When an opportunity presents itself go for it. Nine times out of ten there will be benefits.

146. As previously mentioned, whenever possible include your artworks and/or books in events where you're being recognized.

147. Never underestimate the value of gifting your art to non-profit organizations and other worthy causes. You'll experience spiritual fulfillment as well as exposure for your art.

148. Share all your work-related qualifications with colleges, universities, potential clients and future collaborators.

149. Share your *GOOD NEWS* with your previous and/or potential clients and collectors, and with both the social and traditional media. My author's talk & book signing was a direct result of my doing so.

150. Note, you don't have to be a muralist to have murals. Your painting or paintings can be fabricated into murals by professionals in the field. A list of muralists, in a particular city, can be easily googled.

151. Keep planting seeds from your heart. My continued work with Crystal Stairs must have been the catalyst for this incredible honor. A seed was first planted when Regina Jones commissioned me to create a painting for Crystal Stairs.

152. Don't be discouraged if at first you don't succeed. The first letter that I sent Cheyney went unanswered, but I continued to reach out periodically.

153. In preparation for bookings, whether it be for a college, university, an event or exhibition, make sure you are well rested and health conscious.

154. Be prepared for the unexpected and take out some quiet time.

155. Be open to possibilities. The outcome of my interview with Sandra was unpredictable and amazing!

156. Be prepared. Take some time out to write a generic proposal letter for commissioned artwork and save it to your document file for future use. Make sure to include some basic terms of agreement (i.e. 50% deposit), and a list of prices according to the canvas size.

157. Develop a "Win-Win" attitude. "Win-Win" is a frame of mind and heart that constantly seeks mutual benefit in all human interactions.

158. Just a reminder of the essential importance of research in all our creative endeavors.

159. While interviewing a client regarding commissioned artwork be certain to jot down the answers to all your questions. Then immediately following the conversation, type or legibly write down all the information you acquired for reference.

160. When it comes to deadline crunches it's best to first map out a schedule plan. Include your actual painting time, printing and signing, framing and shipping (all aspects), and then notify all your vendors well in advance.

161. Accepting new and somewhat challenging situations is a definite growth opportunity. My experiences as a "Leader-in-Residence" enhanced my abilities as a lecturer, teacher and counselor for students.

162. The gift of opportunity presents itself whenever we travel. Make a point of seeing and experiencing all possible, even on short work-related trips.

163. Capturing the client's vision, so very important in all commissioned artworks. There-fore our responsibility is to listen very very well, and when in doubt to ask questions.

164. Only when appropriate, include subliminal or obvious visuals in your commissioned paintings to emphasize current events. In "Called To Serve: Inspiring Change" Civil Rights and Social Justice was very relevant to HSSU.

165. Prepare for all your presentations well in advance. You will feel confident and relaxed while enjoying the whole experience.

166. Develop a good work ethic. As a direct result of my good work ethic/traits: emphasis on quality, dependability, dedication, productivity, respectfulness, determination and professionalism, I came highly recommended and received the KSU painting commission.

167. Give your creative ALL to every project large or small. It may come back to haunt you in a positive way.

168. Verbalize your ambitions and they just might manifest.

169. Be proactive. Good fortune happens when preparation meets opportunity.

170. Try to learn something new or useful from each of your events. Music was played during the "Paint & Sip" and it proved to be relaxing for the participants. Music will be included in my future art classes and workshops.

171. When teaching an art class or workshop gift your students with complete freedom of expression.

172. Show your appreciation by giving back.

173. Post all your upcoming exhibits and events on social media and send invitations and press releases to traditional media via email. Melanie Eversley contacted me in response to my post on Linkedin.com resulting in her wonderful interview and published story.

174. Here's a chance to make money while you sleep. But only if you follow through by promoting your collection daily, especially in the beginning. Post photos of the products in your collection with direct links on social media and in emails to family, friends and your collectors.

175. Stay connected, opportunities often reappear through past alliances. Loretta Mask Campbell and I first met at Saint Augustine's University.

176. Step outside of your comfort zone, challenge yourself, take risks and you'll realize your full potential.

177. Leave a positive and lasting impression and opportunity will knock again and again.

178. Devise and plan your events well in advance and in minute detail. Due to the ingenuity of Voncile and Edra the Foundation's 2018 Gala is now a "How can we top this?" event.

179. Stay focused yet open. The difference between impossible and possible lies in your self-determination.

INTRODUCTION TO AFFIRMATIONS

I believe in affirmations for all, but especially for creative people. We have to be self-motivating because of the nature of our work. We work on our own creative schedules, even if we have a full or part-time job. When we create, we have to be very focused. Therefore, we have no room for nagging thoughts.

Affirmations can help charge you up to your creative space. Affirmations are also personal art marketing tools. Because if you're not feeling empowered, how are you going to effectively sell your artwork or yourself for an art project or commission? These thirty-one affirmations can be used in a variety of ways.

They can be spoken aloud, one for each day of the month (with an extra one for the months with only thirty days). You can choose your favorite or favorites and embellish any with your words to make an affirmation more personal. You can read all aloud every day or on any given day when your spirits may need a special lift.

The I Wills According to SAINT JAMES for Artists

1. I will express my individual creativity.
2. I will learn self-discipline.
3. I will be still and believe in myself.
4. I will reach for all my stars.
5. I will accomplish my goals one skip at a time.
6. I will look beyond rejections.
7. I will hush my feelings and paint the day the way I want it to be.
8. I will listen to the beautiful music in the wind.
9. I will listen only to positive suggestions.
10. I will turn on the joy when times get rough.
11. I will make my life a work of art, stroke by stroke.
12. I will steadily plant good seeds that will grow into beautiful plants of success.
13. I will believe in my limitless abilities.
14. I will listen to my own inner alarm system.
15. I will open-up my way to health and prosperity.
16. I will make the most of all circumstances and then let go.
17. I will determine the ultimate outcome of my life.
18. I will direct my thoughts to still waters and feel peaceful.
19. I will give myself permission to be happy.
20. I will take the time to renew and restore.
21. I will use all the positive powers within me.
22. I will stay in tune with harmony.
23. I will take living and life lessons in stride.
24. I will make time for the new as I go about my daily living.
25. I will create my own perfect times.
26. I will greatly respect the power of words.

27. I will bathe in sunshine and be restored.
28. I will lift others up with me.
29. I will empower myself through the words I choose to speak.
30. I will dwell in the "now."
31. I will think courage and strength and become just that.

PARTIAL LIST OF SPEAKING ENGAGEMENTS

African American Atelier, Greensboro, NC
Afro-American Cultural Center, Charlotte, NC
Alabama State University, Montgomery, AL
Albany State University, Albany, GA
Barnard College, New York, NY
Bennett College, Greensboro, NC
Black Women's Network, Los Angeles, CA
California African American Museum, Los Angeles, CA
California Arts Education Association, Palm Springs, CA
California School Library Association, Pasadena, CA
California State University Dominguez Hills, Carson, CA
Cheyney University, Cheyney, PA
Cleveland Public Library, Cleveland, OH
Contra Costa College, San Pablo, CA
Coppin State University, Baltimore, MD
Dartmouth College, Hanover, NH
DePaul University, Chicago, IL
Dillard University, New Orleans, LA
Duke University, Durham, NC
First Peoples Fund, Santa Fe, NM
Fisk University, Nashville, TN
Greensboro Public Library, Greensboro, NC
Harris-Stowe State University, St. Louis, MO
HCA Healthcare Corporation, Nashville, TN
Hilton Hotels Corporation, Beverly Hills, CA
International Reading Association, San Diego, CA
Kentucky State University, Frankfort, KY
Japanese American Cultural Center, Los Angeles, CA
Langston University, Langston, OK
Los Angeles Valley College, Van Nuys, CA
Morgan State University, Baltimore, MD

National Geographic Society, Washington, DC
Natural History Museum, Los Angeles, CA
Neutrogena Corporation, Los Angeles, CA
North Carolina State University, Raleigh, NC
Occidental College, Los Angeles, CA
Orange County Reading Association, Fountain Valley, CA
Pepperdine University, Los Angeles, CA
Phenomenal Phemales, Phoenix, AZ
Rancho Santiago College, Orange, CA
Rust College, Holly Springs, MS
Saint Augustine's University, Raleigh, NC
Saint Louis Art Museum, St. Louis, MO
Simmons College, Boston, MA
Skirball Cultural Center, Los Angeles, CA
Tennessee Association of School Librarians, Nashville, TN
Tennessee Middle State University, Nashville, TN
Tennessee State University, Nashville, TN
The Baltimore Book Festival, Baltimore, MD
The Buckley School, Sherman Oaks, CA
The Wesley School, N. Hollywood, CA
Tougaloo College, Jackson, MS
Toyota USA, Torrance, CA
Tuskegee University, Tuskegee, AL
University of the District of Columbia, Washington, DC
University of Idaho, Moscow, ID
University of Ohio, Athens, OH
University of Redlands, Redlands, CA
University of San Francisco, San Francisco, CA
University of Southern California, Los Angeles, CA
Virginia Tech University, Blacksburg, VA
Voorhees College, Denmark, SC
Washington State University, Pullman, WA

Winston-Salem State University, Diggs Gallery, Winston-Salem, NC
Xavier University of Louisiana, New Orleans, LA

PARTIAL LIST OF COMMISSIONED SIGNATURE PAINTINGS

Africare
Crystal Stairs, Inc.
Sisters at the Well, Inc.
Tea and Conversations
Diversity Women Magazine
American Library Association
Susan G. Komen for the Cure
YWCA of Greater Los Angeles
The Center for Disease Control
Al Wooten, Jr. Heritage Center
Benedict College, Columbia, SC
Bennett College, Greensboro, NC
Children's Institute International
Los Angeles Women's Foundation
Kinship Care Program Baltimore
Stillman College, Tuscaloosa, AL
United Way of Greater Los Angeles
The National Education Association
The Sisters of Providence Foundation
II Sisters Art Gallery, New Haven, CT
Methodist University, Fayetteville, NC
Sankofa Fine Arts Plus, Cleveland, OH
Coppin State University, Baltimore, MD
Kentucky State University, Frankfort, KY
The 100 Black Men of Orange County, CA
Saint Augustine's University, Raleigh, NC
The Origin of the Dream Documentary, NC
California State University Dominguez Hills
Glendale Memorial Hospital, Glendale, CA
Alabama State University, Montgomery, AL

The Natural History Museum of Los Angeles
Museum of African American Art Los Angeles
The Metropolitan AME Church, Harlem, NY
Harris-Stowe State University, St. Louis, MO
North Orange County Community College, CA
Faith Matters-Sisters of Faith, Greensboro, NC
Florida Memorial University, Miami Gardens, FL
Motivating Our Students Through Experience, L.A., CA
African American Visual Arts Association, Baltimore, MD
National Association of African American Honors
Programs
International Association of Black Professional Fire
Fighters
The 20th Anniversary of the 100 Black Men of America
The 20th Anniversary of Tom Joyner's Fantastic Voyage

BIOGRAPHY

Synthia SAINT JAMES is a world renowned multicultural visual artist, and award-winning author and/or illustrator of 17 children's books, several poetry and affirmation books, a cookbook, a play, a monologue, and the autobiographical book titled *Living My Dream: An Artistic Approach to Marketing* (which was nominated for a NAACP Image Award in 2012).

She is also a popular keynote speaker, educator and architectural designer who has garnered numerous awards, including the prestigious Trumpet Award, a Coretta Scott King Award, a HistoryMaker Award, and an Honorary Doctorate Degree from Saint Augustine's University. Dr. SAINT JAMES also serves as a Global Ambassador for Susan G. Komen for the Cure's "Circle of Promise".

Synthia SAINT JAMES' United States Postal Service stamp designs include the first Kwanzaa Commemorative Stamp in 1997 (a total of 318 million stamps were printed using her first design), and the 2016 Forever Kwanzaa Stamp celebrating the 50th anniversary of the Kwanzaa holiday.

Her paintings grace the covers of over 75 books including the original international cover art for Terry McMillan's *Waiting to Exhale* and Iyanla Vanzant's *Acts of Faith*. But few know that her artwork has been featured in many United States Embassies internationally through the Art in Embassies Program since the 1990's.

SAINT JAMES' architectural designs include a 150-

foot ceramic tile mural design for Ontario International Airport's International Baggage Claim, Ontario, CA, six lobby elevator doors for a government building in the Capitol Area East End Complex, Sacramento, CA, three stained glass windows for West Tampa Library, Tampa, FL to identify just a few.

The House of Seagram, Coca Cola USA, Maybelline, Essence Communications, National Coalition of 100 Black Men, Glendale Memorial Hospital, YWCA of Greater Los Angeles, Barnes and Noble and AARP represent a mere sampling of her clients.

Some of her most celebrated collectors include Johnnie L. Cochran, Jr., Alice Walker, Jenifer Lewis, Glynn Turman, Regina Taylor, Brenda Russell, Charles Fuller and Vanessa Bell Calloway.

Awards created by Synthia SAINT JAMES include the "We See You Award", the "Mosaic Woman Award", and "The Lifetime Achievement Award" especially commissioned for His Excellency Nelson Mandela by Africare in 2010.

In celebration of her 50th anniversary as a professional visual artist (1969-2019), Dr. Synthia SAINT JAMES is currently booking her "The Creative World of Synthia SAINT JAMES" tour. This extraordinary tour will include lectures, master classes, workshops, artist-in-residencies, solo art exhibitions, unveilings of fine art commissions and much more.

WEBSITES:

Official Online Art Gallery
Atelier Synthia SAINT JAMES
https://squareup.com/store/atelier-saint-james

The Synthia SAINT JAMES Collection - VIDA:
http://www.shopvida.com/collections/synthia-saint-james

Synthia SAINT JAMES Merchandise - Pixels/Fine Art
America:
http://pixels.com/artist/1+synthia+saint+james

Original/First Website:
www.SynthiaSAINTJAMES.com

CONTACT & SOCIAL MEDIA INFORMATION

Synthia SAINT JAMES
Doctor of Humane Letters
P.O. Box 27683
Los Angeles, California 90027/USA
323.993.5722 (Telephone Messages)
Synthia@SynthiaSAINTJAMES.com
ToBookSynthia@SynthiaSAINTJAMES.com

Facebook: www.facebook.com/synsaintjames
www.facebook.com/people/Synthia-Saint-James/100001685940818
Twitter: https://twitter.com/SynSAINTJAMES
Instagram: www.instagram.com/chisaisaintjames